WEAVERS

OF

TRADITION

AND

BEAUTY

TEXT BY MARY LEE FULKERSON

PHOTOGRAPHS BY KATHLEEN CURTIS

FOREWORD BY CATHERINE S. FOWLER

WEAVERS
OF
TRADITION
AND
BEAUTY

BASKETMAKERS

OF THE

GREAT BASIN

UNIVERSITY OF NEVADA PRESS • RENO • LAS VEGAS • LONDON

 This book was funded in part by a grant from the Nevada
Humanities Committee, an affiliate of the National
Endowment for the Humanities.

The paper used in this book meets the requirements of American
National Standard for Information Sciences—Permanence of Paper
for Printed Library Materials, ANSI Z39.48-1984. Binding
materials were selected for strength and durability.

Library of Congress Cataloging-in-Publication Data
Fulkerson, Mary Lee, 1936–
Weavers of tradition and beauty : basketmakers of the Great
Basin / text by Mary Lee Fulkerson ; photos by Kathleen
Curtis ; foreword by Catherine S. Fowler.
p. cm.
Includes bibliographical references (p.) and index.
ISBN 0-87417-260-8 (pbk. : alk. paper)
1. Indian baskets—Great Basin—Themes, motives. 2. Basket
making—Great Basin. 3. Willow weaving—Great Basin. I. Title.
E78.G67F85 1995
746.41'2'089974—dc20 95-8555 CIP

University of Nevada Press, Reno, Nevada 89557 USA
Book and cover design by Mary Mendell
Printed in the United States of America

9 8 7 6 5 4 3 2

I Love Being Indian!

Being Indian means:
good, tasty, make-your-mouth-water Indian tacos
grandmother's handmade cradleboards with
 small, sleeping, smiling babies
our Shoshone-Paiute language
brown, round, frybread
dancing, happy people with powwows
colorful, bright, like the daylight costumes
Indian People to love
Fat, husky horses in the golden valleys
I love my wonderful Indian Heritage
I enjoy being Indian
God bless all of the Indian People on earth
I'm glad to be what I am
INDIAN!
—Vicki Harney, Owyhee Combined School

CONTENTS

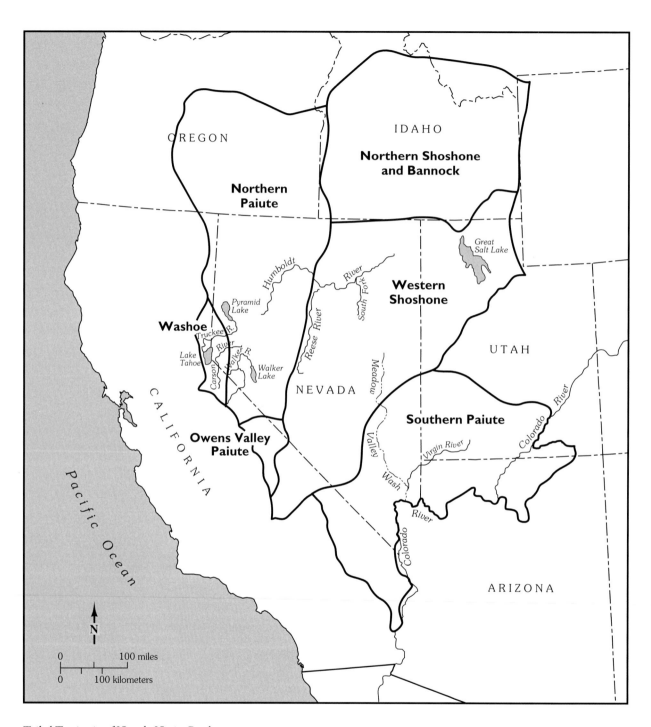

Tribal Territories of Nevada Native Peoples

FOREWORD

The women and men whose "ways with the willow" are recounted in this book have inherited an ancient and time-honored tradition. For countless generations, Native American hands have carefully gathered, split, cleaned, trimmed, and woven willows and other local plants into useful and beautiful containers in shapes both plain and fancy, decorated and nondecorated, but always pleasing to the eye. Mary Lee Fulkerson and Kathleen Curtis, both basket weavers who bring to their work a deep feeling for people and products, tell of the present generation of weavers—some young and some elderly—all dedicated to the continuation of their tradition. For these contemporary Indian people, the willow has been approached with heart, mind, and spirit, and the willow has given in the same way that it did for their ancestors. Their individual stories, here combined in the context of both urban and rural Nevada life, speak for the persistence of the genuine things, things of the hands.

Great Basin baskets, including those from Nevada, are among the oldest and best-dated examples in North America—some reaching back to roughly 9,000 B.C. Baskets are types of woven textiles and thus are related in technique of manufacture to mats, bags, and sandals. But unlike these, which for the most part are flat or flattened, baskets are more three-dimensional (Driver 1961; Adovasio 1986). They may be somewhat flexible or fully rigid, depending on the choice of materials and/or weave structure. For the most ancient people of Nevada, willow was not the first choice; the oldest woven pieces were more often of flexible fibers such as tule (*Scirpus* spp.), rushes (*Juncus* spp.; *Eleocharis* spp.), or shredded bark of juniper or big sagebrush (*Juniperus* spp., *Artemisia tridentata*). When willow (*Salix* spp.) did come into use, it seems to have been used first as whole shoots for both the vertical warp and the horizontal weft elements. It apparently took a millennium or two for basketmakers to learn

the complicated process of splitting it into even strands and cleaning and sizing it properly (see chapter 3).

Contemporary basketmakers share with their ancestors a number of techniques and forms. They have also innovated new shapes and decorative techniques, as did their ancestors at different times in the ancient past. Basket types have come and gone over the past ten thousand years, and they will come and go in the future, but there is also a sameness the world over in how baskets are made, and this guides the hands of even the most innovative. These weaving techniques are closely related to the resulting shape and function of a piece.

The contemporary weavers whose work is featured here use primarily the techniques of twining and coiling—two of the three techniques seen worldwide and well represented in ancient times in Nevada. The third technique, plaiting, was once found here, in the famous Lovelock Wickerware tradition that lasted in Nevada from roughly 1000 B.C. to A.D. 1000. A simpler type of plaiting, which is basically an over/under weave that often features the same elements for warp and weft, was seen in historic times among a few Southern Paiute and Western Shoshone people in southern Nevada. They sometimes used a form of plaiting to make seed beaters, a useful tool in seed collection (see chapter 4 and below). Loretta Graham, a nontraditional weaver whose work is featured in chapter 5, uses a form of plaiting in making her contemporary cradles.

Twining is a type of weaving in which two or more flexible weft elements engage one or more rigid warp elements, interlacing with the warps or being twisted between them. Twining produces flexible or rigid products, making it a useful technique for constructing various basket forms. In fact, of the three techniques, twining is the most flexible in the shapes it can form, as can be seen from JoAnn Martinez's triangular winnowing tray (figure 17), Theresa Jackson's flaring baby cradle (figure 54), Evelyn Pete's conical burden basket (figure 42), and Lilly Sanchez's paddle-shaped seed beater (figure 44). Twined weft rows may be so closely spaced that they almost hide the warp, as in Sophie Allison's plain twined tray (figure 39), or more openly spaced, so that both warp and weft are seen, as in her other trays (figure 35). Whether weft rows go over one warp, or over two with each new row moving over one to form a diagonal (compare figures 29 and 17), twining adds to the interest of this most ancient technique.

In Nevada, twining goes back at least eleven thousand years. It is the primary technique for making mats, bags, and most sandals, as well as the earliest baskets (Adovasio 1986). Some of these early baskets have warps and wefts of twisted tules and were made in the shape of large circular trays (see Adovasio 1986: figure 3). Others are more classically bowl-shaped, such as some of the remarkable finds from Kramer Cave in the Winnemucca Lake basin of western Nevada (Hattori 1982: figure 32). In all, Nevada archaeological sites have yielded many whole and fragmentary examples of twining, making it the best-documented weaving tradition in the region. Radiocarbon dates help to demonstrate its antiquity here as well as elsewhere in North America.

Coiling is a basketry technique in which the warp foundation is wound in a circular pattern and the weft (usually one strand instead of two or more) is sewn over the foundation to link each successive row (see chapter 4). In fact, this technique's relationship to sewing is so clearly recognized by most Indian people, including those here in Nevada, that native words for coiling and sewing are often the same or closely related. An awl is used to make holes for the passage of the weft. Coiling foundations may be of many types; in Nevada, one, two, or three trimmed and evened willow sticks are the most common traditional foundation. Elsewhere, grasses, barks, straight roots or shoots, and combinations of all of these may be chosen. Weavers follow tradition in their selection of materials, as they do with wefts, so that again one can see a long persistence of these choices in ancient types of coiled baskets. One stick as the foundation is clearly visible in Evelyn Pete's round and oval basket starts (figure 23). Several pine needles form the foundation for Larena Burns's nontraditional baskets (figure 88) and several strands of horsehair for Betty Rogers's pieces (figure 94). As with twining, coiled stitches can be so closely spaced that they almost hide the foundation, as in Florine Conway's tightly woven baskets (figure 24), or more openly spaced so that the foundation shows, as in Norm DeLorme's gap-stitch baskets prepared for beading (figure 21). Again, these variations add distinctiveness to the results. The eye can marvel at the tightness of a weave or follow the lined patterns made by widely spaced weft rows.

Coiling is less flexible than twining in the shapes it can produce. It works well for any shape based on the pattern of a circle or oval, which follow the nature of the foundation, and the shape can grow outward by

gradually increasing the area the foundation covers, or it can come inward by reducing that area. The perfection of the slowly growing and then constricting circular shape achieved by Florine Conway (figure 41) illustrates this principle. The use of coiling for knobbed lids by Florine Conway, Minnie Dick, and Betty Rogers (figures 24, 47, and 95) shows some of the flexibility of the technique for creating different shapes.

Coiling does not seem to be a technique used in Nevada's distant past until about 4500 B.C. (Adovasio 1986:200). Nevada's early weavers at various points in time after that created large and beautifully decorated circular trays, apparently for parching and winnowing plant foods (Adovasio 1986: figure 7), large and small widemouthed bowls, and hats. Around a thousand years ago, the large circular tray and the large widemouthed bowl forms seem to have disappeared. Smaller bowl-shaped coiled baskets continue throughout the archaeological record to present weavers. A coiled, pitched water bottle, which is probably around two thousand years old, was recovered from Nevada's Lovelock Cave (see Loud and Harrington 1929: plate 67). It is presently in the Nevada State Museum, which holds many outstanding pieces of Nevada's basketry history and prehistory in trust for all of the state's people.

Given their different shapes and modes of construction, baskets can be and have been used for many purposes. Native people in Nevada have used baskets for such things as food collection and processing, carrying and storing water and other materials, as eating and serving utensils, as bird and fish traps, as hats, as gifts for friends and relatives, and as treasures to enjoy. It is in many of these functions that we also see good examples of flexibility of form. From the present selection, we see the use of triangular trays in winnowing and sifting (figure 36) and for parching (figure 46), cone baskets for collecting piñon pinecones and nuts to be carried back to camp (figures 42 and 57), beaters for knocking large seeds or nuts into a twined tray (figure 44), cradles for swaddling and carrying a child (figures 51 and 29; plate 16), hats for protecting the head (figure 76), lidded baskets for treasures (figure 47), and pitched baskets for water (figure 105). Each has a distinctive form and weave, befitting the task. In fact, each is an eloquent statement of the complex interrelationship of form and function.

In the distant past, additional types of baskets were commonly made

that are little seen today. These include mush boilers, twined hats, and twined water bottles. The mush boilers—large open-mouthed coiled baskets among the Washoe and Western Shoshone people and large twined ones with a sturdy edge among the Northern Paiute people—were once indispensable. They were used for boiling all mushes and stews, with fire-heated smooth stones added to the liquid to provide the heat. These were displaced by metal pots and pans by the 1870s or 1880s. A few people persisted in using their heirloom boilers to maintain tradition and also to impart a special flavor to special foods, but weaving them was rarely attempted after the 1880s. Twined hats were once equally vital for women because they protected the head from the sun and the forehead from the tumpline from which the burden basket might be suspended. Today they are rarely made, although Robert Baker Jr. is taking up the challenge (figure 76). Another basket type rarely made today is the twined water bottle. Note that the one Evelyn Pete is pitching in this work (figure 107) is coiled, an alternative weave for this vessel in the eastern Great Basin. But the distinctive, nearly bipointed shape of the twined water bottle was once the most common basket shape associated with western Nevada (Fowler and Dawson 1986: figure 2). Some were made in a canteen size for travelers, others to hold a gallon of water for a day's food-gathering trip, and yet others to hold five gallons or more to serve as the water supply for a household. All-important to dry-land dwellers, a supply of cool, fresh water was always at hand. Many people recall the special flavor given to the water by the piñon pitch and long to taste it once more. Someday, weavers may again try these shapes along with the others they have mastered.

Design is an important part of basketry and is as old as the art itself. In the past, each tribe had its own unique design techniques, patterns, and motifs. Some were derived from the worldview of the culture and the ecological setting of the group; others were seen among neighbors or dreamed as one slept. Design traditions can often be used to help identify the tribal affinity of a basket (if unknown), the historical period in which it was produced, and its maker.

Basketmakers usually have a total design concept in mind for each new basket before they begin to weave. This concept can govern choice of materials, weaving technique, and overall shape and size. Designs come

from the creative interpretation of the weavers' traditions, and no two are exactly alike.

Choice of materials, especially combinations that contrast in color or texture, often produces pleasing designs. In the baskets presented here, JoAnn Martinez chooses bracken fern for a nice black-banded half-diamond design (figure 17), and Florine Conway uses redbud for her zigzag-and-spot combination (figure 63). Both are working against a basically white ground created by the willow. Norm DeLorme, on the other hand, chooses the black of devil's claw for the body of his basket, with just a bit of white willow for contrast (figure 15). Contrasting light and dark strands of horsehair for foundation and/or stitching adds interest to Betty Rogers's pieces (figure 94). Textural contrasts, such as those produced by whole rods versus split elements or close weave versus open weave, also work as part of the design (see figures 17, 21, 35 and 41).

Weavers who choose to embellish the surface of their baskets follow some long-standing traditions as well as more recent innovations. Nevada's archaeological sites have produced beautiful feather-decorated baskets (and hats)—seemingly woven around two thousand to three thousand years ago (see Elston 1986: figure 12). The Washoe people are also known to have made beautifully feathered baskets in historic times (Fowler and Dawson 1986: figure 6d). The decoration of baskets with shell beads is not documented archaeologically, not even for the early historic period. Glass seed beads, introduced into the region after white contact, were used to decorate buckskin by appliqué or were woven into bands on bow looms in the last century. Applying them to the surface of baskets in the netted technique presently used by weavers such as Bernadine and Norm DeLorme (figure 2; plate 15), Rebecca Eagle Lambert (figure 81), Irene Cline (figure 60), and Betty Rogers (figure 95) began in the second decade of this century (Bates 1979). Sandra Eagle's minimal use of beads sewn between willow stitches, as well as her feather and shell-bead decorations, are her own innovations (figure 71), based on local as well as California Pomo work (see chapter 5). Likewise, the decorative lacework tops of Larena Burns's pine needle and raffia baskets (plate 17) are her own adaptations.

Choice of weaving technique suggests some designs as well, although one often sees similar designs in different techniques. For example, di-

agonal twining, because of the twilled effect it produces, lends itself to designs built on a diagonal, diamond, or half diamond (see figure 17). Because the weft stitches include two warp rods between each turn, designs are often two stitches wide, as can be seen in the two darker bands of JoAnn Martinez's close-twined tray (again, figure 17). Florine Conway sometimes builds diagonal patterns into her close-coiled bowls (figures 41 and 62) by moving the pattern up and over a row or two as the coil foundation builds. The size of the coil often contributes to how the pattern is worked out as well as the kinds of design elements that are used. For example, unless the coil foundation is quite small, rounded edges on a design are difficult to achieve; they appear more stepped than rounded. None of the weavers represented here has attempted such a design, but some very interesting and difficult designs of this type can be seen on older pieces (see Fowler and Dawson 1986: figure 12). Human figures with round heads, rounded shoulders, and rounded bodies are particularly hard to achieve unless the coil size is small.

Weavers usually have an overall layout in mind when they choose to do a decorated piece. One can see on Florine Conway's coiled pieces in figures 41 and 62 the use of layout principles. There are three diagonal bands on the latter basket, going from near the bottom to near the rim. Each of those three bands is separated by two interconnected triangles, precisely placed and equidistant from each other. Conway's basket in figure 63 has a zigzag in redbud with five points. Between each point is a small diamond (five of these in all). Keeping perfect balance—that is, making all elements the same size and equally spaced—represents high achievement in design. Weavers must often count stitches and/or use the joints of their fingers as gauges. They rarely make sketches, nor did the weavers of old. The weaver carries this layout in her head, because she has to make many proper decisions during the weaving process to make it come out right. Washoe weavers, such as Louisa Keyser (Dat-so-la-lee), Maggie Mayo James, Lena Frank Dick, Scees Bryant Possock, and others who wove from the turn of the last century until the 1930s, became particularly noted for their layouts and designs (Cohodas 1983). Northern Paiute weavers from the Mono Lake area and elsewhere achieved much the same quality of design (Bates and Lee 1990).

The influence of layout can also be seen on the beaded baskets that are

illustrated in this work. Note the complex layouts and balance of Irene Cline's baskets (plate 19). Basal designs are sometimes made up of three or four small elements, connected or not connected. These may grow into a complex of other geometric motifs, sometimes encircling the entire basket, sometimes opposite each other, and sometimes combined. Bernadine DeLorme's basket with multiple butterflies in varying sizes is another excellent example (plate 15). And Betty Rogers's design with central medallions set apart by upper and lower zigzag and spot bands (figure 95) is another. Multiple colors also make these beaded baskets glisten! The beadwork on Avis Dunn's and Minnie Dick's cradle tops similarly exhibit thoughtful design and careful execution (figures 25 and 51; plate 16).

Indian people as well as non-Indians have been collectors of baskets for a long time. There were probably always heirloom baskets to be handed down in families and gift baskets to be given to friends and relatives. Sometimes these pieces needed to accompany the maker upon death, because they were considered extensions of the spirit. In Nevada, however, ever since the development of baskets made specifically for sale or trade—probably soon after white settlement in the 1850s and 1860s—collecting has become a more earnest activity.

Most Nevada ranches at the turn of the century had one or more baskets; some shop owners promoted sales and particular weavers, giving local baskets a much broader appeal (Cohodas 1983). Tourist markets, such as Lake Tahoe, Yosemite National Park, and others, also promoted collecting, as did the general "craft movement" up through the 1930s. This was when some of the truly fine collections of Nevada baskets presently held by museums, both local and national, and among some private individuals came into being.

Today, these older baskets and collections have entered the art market even more dramatically, with the price structure of pieces sold through Sotheby's, Christie's, and many national and local dealers reflecting increasing values. Contemporary weavers, including those whose work is featured here, are beginning to compete in this market and will undoubtedly be even more active in the future. Their work will find its place alongside that of their ancestors as treasured items—a place well deserved and long overdue.

Catherine S. Fowler
University of Nevada, Reno

REFERENCES CITED

Adovasio, J. M. "Prehistoric Basketry." In *Handbook of North American Indians*, edited by W. L. d'Azevedo, 194–205. Vol. 11 (Great Basin). Washington, D.C.: Smithsonian Institution, 1986.

Bates, C. D. "Beaded Baskets of the Paiute, Washoe, and Western Shoshone." *Moccasin Tracks* 5, 1 (1979): 4–7.

Bates, C. D., and M. J. Lee. *Tradition and Innovation: A Basket History of the Indians of the Yosemite-Mono Lake Area*. Yosemite Association, Yosemite National Park, California, 1990.

Cohodas, M. "Washoe Basketry." *American Indian Basketry* 3 (1983): 4–30.

Driver, H. L. *Indians of North America*. Chicago: University of Chicago Press, 1961.

Elston, R. G. "Prehistory of the Western Area." In *Handbook of North American Indians*, edited by W. L. d'Azevedo, 135–48. Vol. 11 (Great Basin). Washington, D.C.: Smithsonian Institution, 1986.

Fowler, C. S., and L. E. Dawson. "Ethnographic Basketry." In *Handbook of North American Indians*, edited by W. L. d'Azevedo, 705–37. Vol. 11 (Great Basin). Washington, D.C.: Smithsonian Institution, 1986.

Hattori, E. M. "The Archaeology of Falcon Hill, Winnemucca Lake, Washoe County, Nevada." *Nevada State Museum Anthropological Papers* 18. Carson City, Nevada, 1982.

Loud, L. L., and M. R. Harrington. "Lovelock Cave." *University of California Publications in American Archaeology and Ethnology* 25, 1 (1929): 1–183.

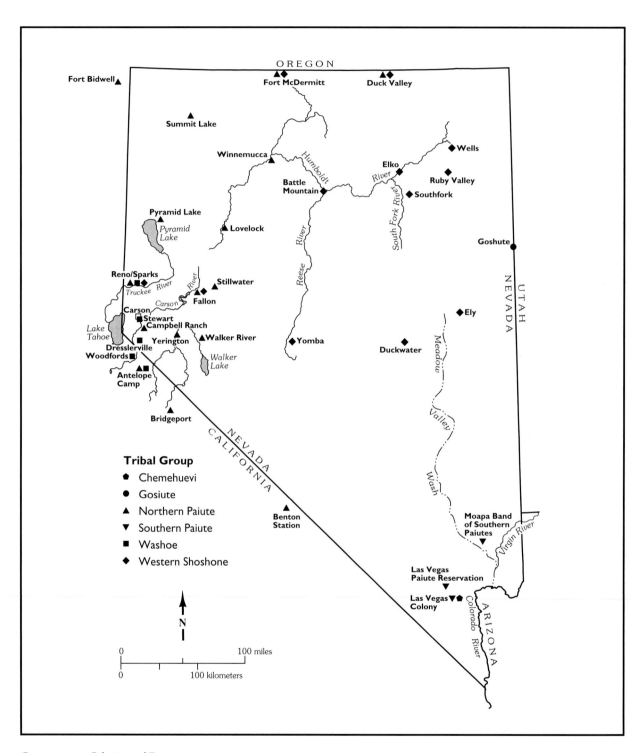

Fort Bidwell▲

OREGON

Fort McDermitt▲▲　Duck Valley▲▲

Summit Lake▲

Winnemucca▲　Wells◆

Elko◆　Ruby Valley◆

Battle Mountain◆　Southfork◆

Pyramid Lake▲

Pyramid Lake

Humboldt River

Reese River

South Fork River

Goshute●

Lovelock▲

Reno/Sparks▲■■

Truckee River

Carson River

Stillwater▲

Fallon◆

Carson

Stewart■

Campbell Ranch▲

Yerington■

Walker River▲

Yomba◆

Ely◆

Duckwater◆

Lake Tahoe

Dresslerville■

Woodfords■

Antelope Camp■

Walker Lake

Meadow

Valley

Wash

NEVADA / UTAH

Bridgeport▲

NEVADA

CALIFORNIA

Tribal Group

⬟ Chemehuevi

● Gosiute

▲ Northern Paiute

▼ Southern Paiute

■ Washoe

◆ Western Shoshone

Benton Station▲

Moapa Band of Southern Paiutes▼

Virgin River

Las Vegas Paiute Reservation▼

Las Vegas Colony▼⬟

Colorado River

ARIZONA

N

| 0 | | 100 miles |
| 0 | | 100 kilometers |

Contemporary Colonies and Reservations

PREFACE

We—photographer Kathleen and writer Mary Lee—are longtime friends, basketmakers, and artists whose work, conversations, and ceremonies reflect the deep influence of other cultures—cultures where people live close to, and honor, the rhythms of the earth. So when, one autumn day from her home at Donner Lake, California, Kathleen called Mary Lee at her home near Pyramid Lake, Nevada, and proposed this book, it was a natural next step in our mutual quest to learn the lessons and ask the questions from those who know the answers—the Indian people.

That phone conversation was the beginning of an odyssey that was meant to last a couple of months but stretched into years. The easy part was unraveling the mysteries of cameras, computers, and road maps. More difficult was finding the People, through a network we'll call the "Indian grapevine." We followed leads and from them received more leads; we traveled the back roads and reservations of Nevada. We lost tires and mufflers, heard stories under the stars, tasted wild onions and parsley, got lost, rejected, and sunburned, danced in circles and sweated in lodges, and in the process we found a common bond with Indian people in a mutual respect for basketry. And although this book will never convey everything we found, it is a beginning.

We had a lot to learn about a lot of things, but the greatest thing we learned was respect. Respect for those who are trying to learn this challenging and time-consuming process. And respect for people who continue the strong traditions of their ancestors despite odds that would deter most individuals.

Although baskets from the Great Basin are not as highly patterned and do not contain the rich material mix found in baskets of many other tribes, they need to be honored on their own terms. Some of the styles date back thousands of years and made living in the Great Basin possible.

Their primary material is willow. This one simple little plant has produced miracles—basket miracles. The baskets in this book are testimony to the enduring strength that comes from generations of a proud people.

Having to confine our focus to nineteen weavers from within the boundaries of Nevada has been most frustrating, and this work neglects other determined Washoe, Western Shoshone, and Northern and Southern Paiute weavers working in eloquent persistence both within and beyond state borders. We are sorry we could not include the following basket weavers, who are also carriers of their tradition: Elsie Allen, Mamie Nez, Margaret Houten, Lena Murphy, Deborah Christy, Jenny Dick, Ruth Johnson, Virginia Sanchez, Grace Frasier, Cye and Gladys Hicks, Marilee Teton, Brenda Hooper, Shirley Brady, Cynthia Rodriguez, Elaine Smokey, Rosemary DeSoto, Agnes Foster, Tammy Crawford, Marie Kizer, Martha Dick, Elizabeth Williams, Elmira Copeland, Norma Williams, Molly McCurdy, Rema John, Rozina Sampson, Clarice Bliss, Goldie Bryan, Reese Allen, Helen Williams, Flora Greene, and all the others we have yet to meet who are indeed living repositories of their culture. It is our hope that one day a person will appear with the resources to seek out baskets and their makers from each of the Great Basin tribes in all of their territories.

A major disappointment was not being able to locate a traditional basket weaver from southern Nevada; with the retirement of well-known basket weaver Mary Lou Brown, a Southern Paiute/Chemehuevi from the Colorado River Reservation, and the death of Topsy Swain, also of southern Nevada, we could find no other traditional weavers. However, Lena Murphy of the Walker River Indian Reservation at Schurz is pretty sure there are weavers down there, because "they've got good willow there at Moapa."

Most Native Americans we interviewed refer to themselves as Indians or Indian people. We have honored this and other expressions and included them whenever possible. All of the weavers are highly intelligent women and men speaking from their own culture; we have tried to preserve the integrity of the way in which they explain their work.

Offerings of thanks go to the basket weavers who appear in this book; they gave generously of their time and knowledge. They shared their culture with us so that we in turn could share it with you, the reader. We have

attempted to make this the People's book. Not our book, not the historians', scientists', or the spiritualists' book. Theirs. The weavers have read and approved every word we wrote about them. There was much they asked us not to include, such as the loss of their cultural connections during forced attendance at the Stewart Indian School, a Bureau of Indian Affairs Boarding School located near Carson City. (This school has been transformed, as you will soon read.) We heard stories about hiding in the mountains to avoid the sheriff, who would forcibly take Indian children from their families and place them at Stewart—some for years at a time. There, said one weaver who asked for anonymity, "they would wash our hair in kerosene, check us inside and out, and spray us with powder."

It seems impossible that anyone could hold on to a family basket-weaving tradition after that experience. Some did, however, and thanks to them, the basket tradition in Nevada endures.

A portion of the sales proceeds from this book will be given to the University of Nevada anthropology department's Lulu K. Huber Basket Collection and to the Washoe Cultural Center.

ACKNOWLEDGMENTS

The authors express their deep gratitude to Norm DeLorme, an accomplished basket weaver in his own right, a man with a lifetime dedication to keeping the culture of Great Basin Indian people alive. Norm's suggestions and background information were an important resource.

Many thanks to the persons and groups who helped with their own gifts when we needed them most, especially to the Nevada Humanities Committee and the Origins Archeological Consulting Company. Also thanks to Anthony Moore; Gineice Carter; the Washoe Tribe Education Department; Bernice Servilican; Leah Brady; Joe Sanchez Jr.; the Nevada Department of Education; Senator Harry Reid; the Inter-Tribal Council of Nevada, Inc.; Lisa Shurtz; Shereen LaPlantz; Citizen Alert; Jean May; Kit Miller; the Special Collections Department of Getchell Library, the University of Nevada, Reno; Barbara Horn of the Indian Arts and Crafts Board; the U.S. Department of the Interior; Loretta Pepion, Museum of the Plains Indian, Browning, Montana; and Maury Hicks.

Great Basin people are fortunate to have a strong and heartfelt advocate in Catherine S. Fowler, University of Nevada, Reno, anthropologist and professor. Her detailed study of Great Basin anthropology in all its phases has helped us all to see the glory and wonder of this land with new eyes. In many instances, the basket weavers have been encouraged to continue their traditions as a result of Professor Fowler's unwavering advocacy.

Last but not least, we would like to express our gratitude to our husbands, Chuck Fulkerson and Dick Curtis, for their support in so many ways.

WEAVERS

OF

TRADITION

AND

BEAUTY

U.S. Highway 6, facing Black Butte, in the Nevada desert.

THIS DYNAMIC LAND

Nevada lies at the heart of the Great Basin—a vast area where a magnificent inland sea once covered more than 9,000 square miles.[1] Over the last 25 million years, gigantic forces pulled the land apart nearly 50 miles,[2] forming dozens of desert basins and great craggy mountains that climb as high as 14,000 feet.[3] The water eventually receded, and today only two lakes from that system have not gone dry—Pyramid Lake and Walker Lake. It is an unpredictable desert, with rivers and streams that drain inward and a climate of cold, snowy winters and hot, dry summers. Average annual precipitation (9 inches) is the lowest of the fifty states. Temperatures fluctuate widely (Elko in north central Nevada, near the present home of Shoshone elder Minnie Dick, boasts a 150-degree temperature range).[4]

During the many thousands of years that Native Americans have occupied this desert, it has continually unfolded with contrasts and change, hosting everything from marshlands and coniferous forests to subalpine tundra and rich river vegetation. Forests and woodlands marched down and up the mountainsides, desert playas brimmed over, and marshlands drowned. In a single year, from 1889 to 1890, Pyramid Lake rose 16 feet. Nearby Winnemucca Lake was apparently dry before 1850, then rose to a depth of 85 feet, hosting a flourishing commercial fishery in the mid-1880s. It dried up again in 1939 and has been dry ever since.[5]

This dynamic geographical setting piques the curiosity. What sort of players were able to live with this changing scene for so many thousands of years? Why would anyone—then or now—possibly want to live here?

To answer that question, one must go out into the desert.

This vast Great Basin of Nevada, haven to some, wasteland to many, is sprinkled with ranches and mines, lone cabins, cities that beckon, and

hardy frontier towns, all islands of humanity that seem to hang, suspended in their own isolation, in a waving sea of sand, rock, and sage. And this other world, this vast desert away from the cities and towns, seems timeless.

And when, after many miles of sameness, the traveler finally becomes part of the monotony of the desert, a miracle happens, a miracle that only those who have felt its rhythms know: the desert begins to sing its song.

The bare hills and mountains become human landscapes, huge magnificent forms in sculpture. Tiny wildflowers blare stunning colors against parched, mouse-colored dust. Scattered trees heroically defy wind and drought to cling to the earth, to live. Occasionally a watery green valley hums into existence around a turn and dip in the road. And ahh, the biting cold evenings, when the smell of sage envelops a night glittering with thousands of stars spanning a black and abundant sky.

This Great Basin is a land of miracles. Miraculous, perhaps, that water can be dredged from the depths and coaxed around little seedlings, causing crops to grow; miraculous that sheep and range cattle and wildlife actually can live here; miraculous that this seemingly harsh landscape hosts many thousands of human inhabitants and their pets and hobbies and jobs. Miraculous that Native people have lived upon this land for many thousands of years.

2

THE
PEOPLE

Indian people lived in the Great Basin before the wells were dug, lakes and rivers fought over, trails and highways forged. According to Western Shoshone basket weaver Lilly Sanchez, Shoshone creation stories say their people originated in the Great Basin. "We didn't come over on any land bridge," scoffs Joe Sanchez Jr.[1] Washoe people say they came to their land in the beginning and have always lived here.[2] And Paiute oral tradition also tells of originating in the Great Basin:

> All kinds of animals were people before men came on the earth. There was a man down by a mountain and a woman came to him out of the ocean in the south. She went down some mountain and got to a lake. After the flood she reached Job Mountain. With the man she made Indians.[3]

The People tell us their ancestors adapted to their environment well. They built shelters and knew which medicine plants could be used to cure illness. They knew when the berries and nuts were ready to harvest and where and how to hunt and fish. They lived with the seasons and breathed their desert space with intimate oneness.

Some have called it miraculous that so many of the People have survived the white way of life. They carry on despite loss of traditional Native lands and the limitations of reservation living, high rates of joblessness, nuclear testing and military bombing on their sacred land, use of pesticides, the cutting down of the piñon trees, a primary food source, and a general loss of honor visited upon them by more than 160 years of white invasion and interference.

Many of the People retain an intense spiritual identification with the natural world around them. Elders describe medicine plants that grow or once grew in certain desert places, and many of the old foods such as

squirrels, pinenuts, and acorn soup are still considered delicacies. Many describe, or are relearning, their traditions and beautiful languages despite years of white efforts to eradicate them at the Stewart Indian School near Carson City, Nevada, where live-in attendance was required and enforced, and students were only allowed to return home for a short time in summer.[4] Dances, powwows, and festivals continue to thrive, their numbers growing in magnificent leaps, as Native pride asserts itself in Nevada.

Native pride has always been around, however, when it comes to basketry. The People from three of the four Nevada tribes—Washoe (Wa She Shu), Western Shoshone (Newe), and Northern Paiute (Numa)—are still making their baskets in the old way, still gathering the willow, still hoping a young person in the family will want to learn, still seeking and finding the rhythm of the earth. We were unable to locate any active traditional basket weavers from the fourth great tribe, the Southern Paiute (Nuwuvi).

BASKETMAKING: A LONG, STRONG TRADITION

The basketry tradition in the Great Basin goes back eleven thousand years and has continued longer than any other basket tradition in the country,[5] perhaps even the world.[6] And when Indian people of Nevada begin to speak about their baskets, bits and pieces of their priceless heritage burst to the surface like stars in the great Nevada sky. Given the importance of baskets in their lives and history, it is not surprising that ceremonies, dances, legends, and creation stories surround the baskets as if by magic. All life is, after all, intertwined, the People say.

One chilly spring night a group of us, wrapped in blankets and hunched around a popping campfire at the Duckwater Reservation, listened to Joe Sanchez Jr., a member of the Western Shoshone tribe, as he talked about the importance of baskets to the Newe. Joe Jr. said Shoshone chiefs might stand forward and make all the decisions, but the women, no doubt, had already told them what to say. Food was gathered, stored, distributed, and fed to the people by the women, in baskets especially made for certain designated purposes. Mr. Sanchez said women controlled the food technology and men respected and appreciated that. "So the men listened to the women so they wouldn't starve," he finished.[7]

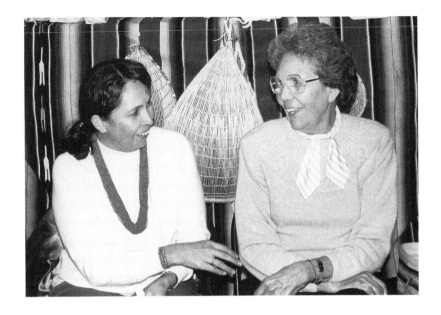

Fig. 1. *Bernie DeLorme and her mother, Lilly Sanchez, visit during the Reno-Sparks Indian Colony Art Market.*

In our search for Nevada's Native American basket weavers, their work, materials, and their stories, much of what we learned was not what we were seeking. Some of the greatest and deepest truths emerged almost accidentally as we interviewed, listened, and shared information. We found that while basket designs from the three different tribes sometimes overlap in a friendly sort of way, at other times a tribe—and within that tribe, a family—will keep its own style separate and distinct from those of the others. And while material and technique may be almost the same, each person has her or his own distinct "hand." Eventually even we two white interviewers began to identify a basket's maker by the way it sat or was woven. (I was present at the Gatekeeper's Museum in Tahoe City when Mr. Norm DeLorme looked at the Native American baskets on display and immediately identified several made by the hands of his late great aunt, Celia Arnot, and other weavers as well.)

We also found that a proud adherence to a weaver's own tradition is accompanied by an open and genuine interest in and appreciation for the basketwork of others. Respecting the differences in others, coupled with strong adherence to one's own tradition, was a valuable lesson the People taught us.

We non-Indians are very fortunate. It is still not too late to learn from

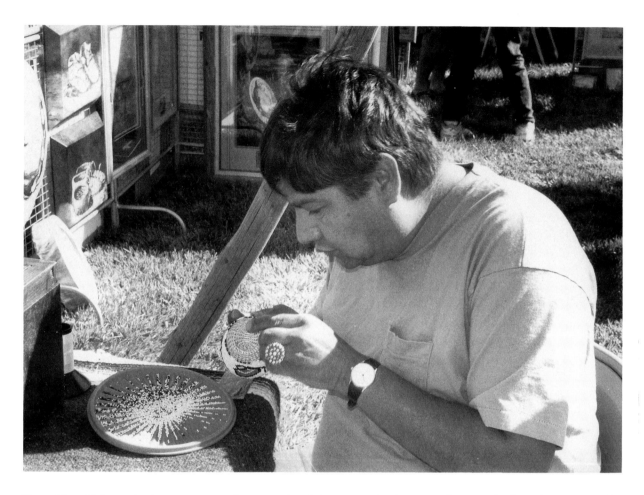

Fig. 2. *Norm DeLorme beading a basket at the Reno-Sparks Indian Colony Numaga Indian Days.*

these people of the sage, who have much to teach about honoring tribal and family traditions, living in harmony with the rhythms of the land, and accepting differences in each other while following our own sure path.

Why, we ask the basket weavers, do you continue making the baskets of your ancestors in a world of cheap and handy paper, wood, and plastic? It is a strange question for them. We might as well ask why they are alive on this earth. They answer in a roundabout way and hope we understand: they talk about watching mothers, aunts, and grandmothers gathering willow, preparing materials, weaving the baskets, sitting by the river, weaving cradlebaskets for their children's dolls, laughing, teaching, telling stories. Lilly Sanchez says when she makes a basket she thinks about her people who first showed her how to prepare the willows. She

thinks about her people "way back" and how they used the baskets. Other weavers remember winnowing the pinenuts, and many still go pinenutting. And there's still no substitute anywhere for a good cradlebasket.

Norma Smokey, a newcomer to the field, has been deeply moved by her basket-weaving experience. She says reverently, "You're creating something with your hands, and the willow becomes a part of you." And with a grand yet simple eloquence, Rebecca Eagle says it for all the basket-makers: "You have a feeling in your hands, like an instinct."

All of the weavers we interviewed seemed to have that "feeling in their hands." The basketwork is long and hard, from gathering the materials to the final tuck, performed with assurance, love, and a fierce and quiet pride in the knowledge passed to them from countless hands through untold generations.

3

THE MATERIALS

WILLOW

Basket weavers from all three tribes use willow as their primary—sometimes their only—basket material.[1] Why willow? Because, miraculously, it is there. It's one of the few materials that will grow in Nevada's green fields and along ditch banks and desert streams; and, difficult as it is to believe, a good willow stand can be transformed into a variety of strong, white, beautiful baskets. Magic? No, although it seems so. The transformation is made through the knowing hands of determined Native Americans who believe their traditions hold the key to their strength.

Willow is a tough, hardy survivor, firm, yet yielding, much like the people who use it.

Gathering

Washoe basketmaker Florine Conway says, "Indian people appreciate baskets more than non-Indians because they know what it is to get your materials." And she's right.

Willow is gathered only at certain times of the year, beginning in autumn after the leaves fall. For many of the weavers, gathering will continue until the following spring when the sap begins to rise again.

The various weavers each have their personal areas, times, and kinds of willow to select. Washoe weaver JoAnn Martinez says willows gathered in fall are a beautiful orange color. For Schurz basketmaker Irene Cline, Thanksgiving is the best time to pick. She says the willows are stronger then and adds that they are better in higher altitudes. Some weavers say the red willow that grows at Yomba, an Indian reservation located in the Reese River Valley in central Nevada, is best. Rebecca Eagle of Wadsworth says you must have "an eye for looking at willow." "And you

have to find the right kind of willow—not just any kind will do," adds Shoshone basketmaker Bernadine DeLorme. She says that out of about twenty species of willow, only three or four types can be used for the baskets. JoAnn Martinez looks for *pa-chella*. *Pa-chella* means "mouse" in the Washoe language; these mouse-colored willows are very strong. Robert Baker Jr. has a secret spot where he looks, but the good willow doesn't always come up each year. "It goes in cycles," he says. Some gatherers, once they find a good stand, will cut as much as they can. Some cut what they need for an upcoming basket; others cut a whole winter's worth of basket willow at one time.

Destruction of willow

Some of the basketmakers, like Minnie Dick, Emma Bobb, Theresa Temoke, Evelyn Pete, and Irene Cline, are lucky—willow grows abundantly within a short distance of their homes. But the greatest challenge to most gatherers is finding the right willow. Subdivisions and high-rise buildings cover many of the old willow patches. Bernie DeLorme and her husband, Norm, a basket weaver also known for his beadwork, drive long distances—from 5 to 100 miles—to find the right kind. Housing developments have covered the land nearby where they and their people once gathered lush basket willow. Irene Cline worries because the ditch banks

Fig. 3. *Reese River and willows on the Yomba Reservation.*

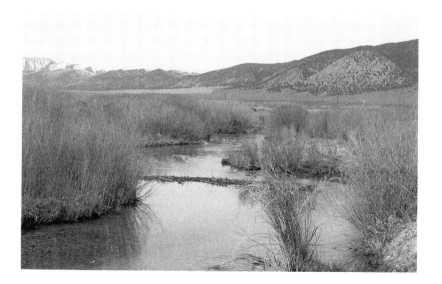

9

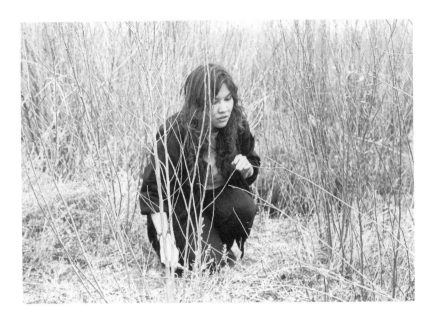

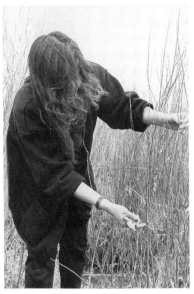

Fig. 4, left. *Rebecca Eagle Lambert kneeling in a stand of willow and looking for just the right ones.*

Fig. 5, right. *Rebecca carefully examining the willow before cutting.*

where her willows grow are being lined with concrete. Arthur Dunn traveled 120 miles to Cedarville, California, to get the firm, healthy willow sticks his wife, Avis, uses to make the strong backs of her award-winning cradlebaskets. JoAnn Martinez and Theresa Jackson recently found a locked gate blocking the road to one of their traditional gathering places.

Pesticides

Often herbicides and pesticides have been sprayed on the willow by farmers and developers. "Sometimes," says Theresa Jackson, "when you take their [the willows'] skins off, they have spots from pesticides." Lilly Sanchez says the plants then grow deformed: the shoots don't grow straight and the willows are bumpy and wormy inside. "Once, when I first started making baskets, I gathered willows like that along the Carson River. My husband and I gathered two big bundles of them. But when I took them home and started working with them my mouth started getting numb. That was when I knew those willows had been sprayed with chemicals. They'd been poisoned."

To comments by non-Indians that there aren't any negative pesticide effects on the willow, JoAnn Martinez retorts, "Don't tell me it doesn't affect the plants. You can even smell the spray! And when you put it in

your mouth, you can tell." JoAnn, Theresa Jackson, and others with them stay away from river drainage places and along highways. JoAnn continues: "Most people aren't aware because they don't work with plants. They don't know what it [pollution] does to your skin, what it does to the water. The poor plants are deformed and brittle."

JoAnn adds, "Some plants only grow at certain elevations. When the habitat is gone, there goes your plants. And some of them are just as valuable as those that grow in the rain forests."

University of Nevada, Reno, anthropologist Catherine S. Fowler puts it more succinctly: "The willows are either poisoned by ranchers or plowed under by developers. They are eradicated without people realizing the willows have another function—the maintenance of a culture." [2]

Offerings of thanks

A number of the weavers we interviewed make offerings of thanks. It is a way of giving respect to the land as well as to the materials they're about to use.

Lilly Sanchez, a proud traditionalist, always gives an offering—pennies, tobacco, or another plant—to the willows before cutting. "If you

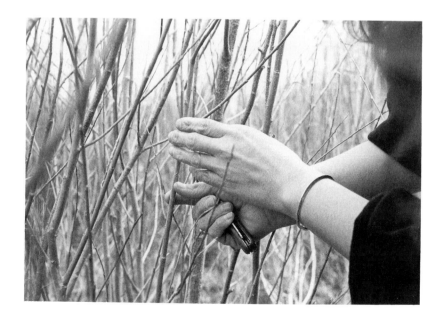

Fig. 6. *Rebecca holding her knife ready to select the right willow.*

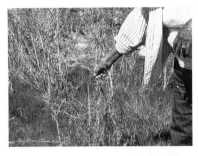

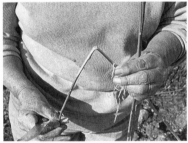

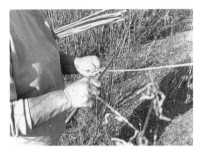

Fig. 7, top. *Evelyn Pete bending a willow to test its strength and flexibility.*

Fig. 8, middle. *JoAnn Martinez showing that when a willow stalk is not of good quality it will break rather than bend.*

Fig. 9 bottom. *JoAnn peeling a stalk of willow as she checks for quality during a gathering expedition near Carson City, Nevada.*

don't, they'll just die off," she instructs, adding that not enough people know to do this now.

One who follows the offering tradition of his people is Robert Baker Jr. A deeply spiritual man, Mr. Baker takes the entire process very seriously. Before gathering any willow, he goes into a deep, prayerful concentration; an offering is then left at the gathering place. "When you do something like that," he explains, "you're opening up the opportunity for the willow to cooperate when you weave. That's all part of why it [the basket] comes out so good."

Testing and sizing

Once an area has been located, different sizes are gathered for different parts of the basket. Willows for thread or strings must be thin, with no knots or branches coming out of them. Some willows will become the backs or hoods of cradlebaskets, and others will be foundation rods for round baskets or support rods for winnowing trays and burden baskets.

As the women pick the willow, they test it. It must be supple and smooth. If the tips are dry, there hasn't been enough water in the area. Rods are bent between thumbs; if they crack, that means they're wormy inside. There can be no bumps or the resulting thread will break during the weaving process. An entire basket can be ruined with just one bad willow.

Splitting the fresh willow is one of the trickiest parts of the entire process: it is split into three parts with the mouth, teeth, and hands. Some people start splitting from the butt end; others, from the top—whichever way they have learned. The willow must be pulled equally in all three directions to keep the pieces evenly sized all the way down. This process is so difficult that not everyone can learn to do it. If they don't, their basketmaking career is ended before it really begins. For the gathering and preparation is the first step in learning to make the basket.[3]

"It took me a long time to learn to split," says Norma Smokey, an apprentice with her aunts, JoAnn Martinez and Theresa Jackson. "First I did it with my fingers and they got sore. It was so hard, I saved every little bitty piece." Lilly Sanchez pulls, or splits, into four pieces, and Rozina Sampson remembers her grandmother splitting willow into as many as six strings.

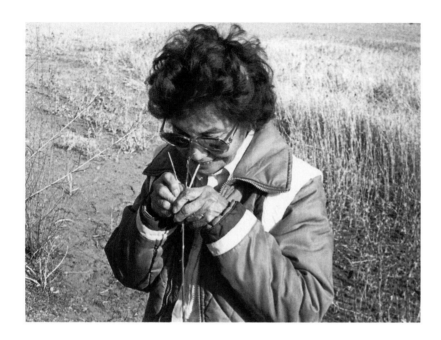

After the three splits are made, the inner core is removed in a process often referred to as "cleaning." "Feel it with your hands," says Rebecca Eagle, "and go slow." Lilly, who removes that core with her teeth, says this is the hardest part to take out. She rolls the split pieces into coiled bundles with the bark left on; it will be peeled off later, when dry.

Some people take the bark off right away. Techniques vary and are as personal as the weaver, but generally the bark is removed from the strand by running the thumbnail underneath the bark along the length of the split piece. (This bark is called "skin" by many of the weavers, an eloquent statement of the human connection with the willow.)

JoAnn and Theresa take off the first layer. The bark is still attached at this point. They peel out the core and remove it. If the willow is good, the core will come right out; the thread is useless without the core coming out. "The sacred third layer is the good thread," they say. (This "thread" is also referred to as "string" by others.)

Fig. 10. *Theresa Jackson splitting the willow into three pieces with her teeth in the traditional way.*

Cleaning

The cleaning process is the most time consuming of all. The bark must be scraped from the large foundation rods. JoAnn uses sixty to seventy

willows for the bottom of a cradlebasket, and each one must be scraped with a special willow knife into a smooth, perfectly round rod that looks and feels like white satin if it's done the right way. She can clean up to fifty a day "when I really get going."

The strings must also be scraped, cleaned, and sized. This is a lengthy operation. "Your fingers get tired and your hands start to hurt," says JoAnn. "It takes a whole bunch of threads even to make a little basket."

Storage

The rolled willow bundles are left to dry in a shady place. Shade helps preserve the beautiful white color unique to the willow and most prized by the People. If the brown color is wanted as a contrast, Theresa says the willow threads can be hung, shiny side out, on a line, and they will turn brown.

Lilly Sanchez wraps her rolled threads with bark, as her aunts and grandmother did, or with strips of cloth. She says her mom used to wrap the bundles in white cloth to keep them from turning brown.

The larger foundation rods are gathered into bundles, tied in several places to keep them straight, and stored upright in a shady place for later use.

The willow, once prepared, can be stored indefinitely. It needs to be moistened again when the basket weaving begins.

Fig. 11. *Lilly Sanchez removing the core from a split willow prior to making threads.*

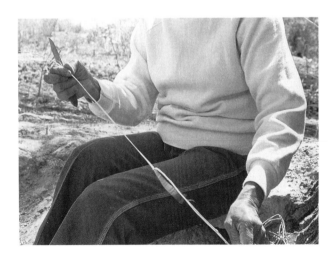

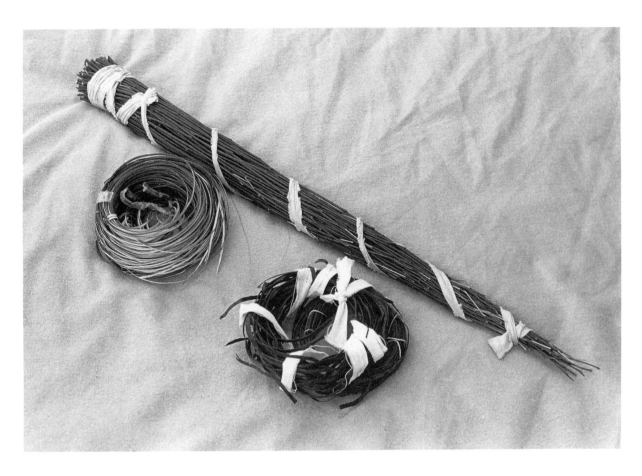

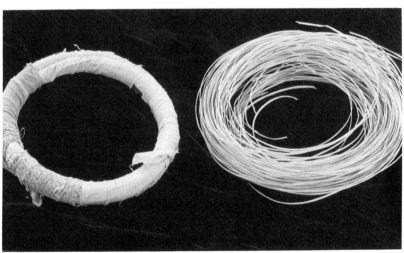

Fig. 12 (above).
Top: Long redbud bundle.
Left: Circular peeled redbud bundle.
Right: Dyed bracken-fern-root bundle.

Fig. 13 (below).
Left: Willow threads that Minnie Dick
has prepared and wrapped to prevent
darkening.
Right: Unwrapped willow threads.

OTHER MATERIALS

Chokecherry[4] is favored by some weavers as a reinforcing rod for frames on cradlebaskets, for winnowing trays, and for the inside of cone baskets, because it is a strong, durable wood. It must be warmed enough to bend, then it is formed and tied to the necessary shape until dry. Avis Dunn's husband, Arthur, warms it with his hands before he shapes it. Other weavers might hold it carefully over a flame; sometimes it is shaped right after it is picked, then tied to dry. For cradlebasket frames, the choke-cherry rod is shaped to a specific form around nails pounded into a board or into the side of a building for just such a purpose.

Red willow, where available, is frequently used in place of chokecherry for the strong frames. Emma Bobb uses a special kind of *birch*[5] for her frames that she finds in a canyon near her home at Yomba.

Color is not always desired in a sturdy, utilitarian basket. But when it is, *redbud*[6] is sometimes used. A beautiful reddish-brown bark from the redbud bush, it was originally obtained by the Washoe people by trade

Fig. 14. *Miniature willow basket by Norm DeLorme with design of redbud and devil's claw. (Collection of Mary Lee Fulkerson)*

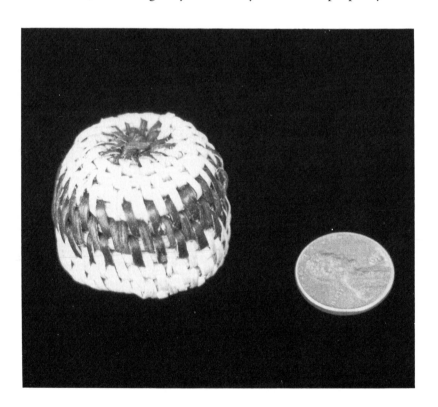

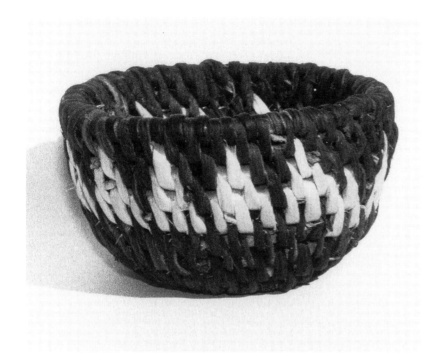

over the Sierra Nevada mountains. Other tribal people sometimes buy or trade for it with Frank Burns, who lives near Carson City, Nevada, and with others.[7]

Emma Bobb uses *wild rose*,[8] a tradition among some Shoshone people, a plant with a great deal of spiritual significance. Norm and Bernadine DeLorme are growing *devil's claw*,[9] using the thread to add a rich black to their miniature willow baskets. Norm and Bernie split each finger of the claw into two or more strips. They soak the claw a little, but it's a tricky process, as they may easily lose the color or break the thread.

JoAnn Martinez received a Folk Arts Program research grant from the Nevada State Council on the Arts to work with an apprentice, Cynthia Rodriguez, to reintroduce the art of gathering *bracken fern root*[10] and dyeing it black in the old way she remembers her mother doing.

Bracken fern root is obtained in the fall when it turns yellow. Mrs. Martinez finds it in traditional Washoe country, in the Lake Tahoe area, around Echo Summit, in the Woodford's Canyon (California) hillsides,

Fig. 15. *Basket coiled with devil's claw by Norm DeLorme. The white design is willow.*

and in other places. Most often it grows on public lands and she must obtain permission from the Forest Service to harvest.

JoAnn looked for soft soil under a dead tree, which is the best place to obtain the root. She says it goes "on and on," up to six feet long, and is very thick. Digging sticks must be used, and Cynthia's husband went along to help the women dig the tenacious root. The root is split into two pieces; inside is a jellylike coating that must be cleaned out with a knife. Scraping it off was extremely hard on her hands, she says. JoAnn remembers that her mother, Sadie Joe Smokey, took bracken fern root to a certain ranch below Minden, Nevada, near the water's edge where the ground was soft. She would bury it there in the mud for two to three weeks and would get a beautiful black for use in baskets. Unfortunately, the rancher released his livestock in the area, and pigs dug up all the precious fern root and ate it. Mrs. Smokey never returned.

To get her color, JoAnn used a galvanized coffee can and filled it with mud from a spring where water is present all the time. It has to be water from a special place, she says—preferably "a hot springs and it must run in a line." She kept the soaking root moist and tested it every few days until it was black—but not as black as her mother's was. To our eyes the root appeared very black, but JoAnn was not satisfied.

Fig. 16. *JoAnn Martinez dyeing bracken fern root in the black mud traditionally used for this purpose.*

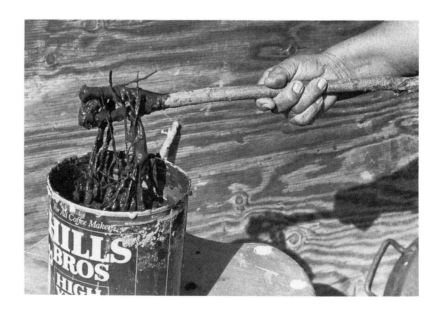

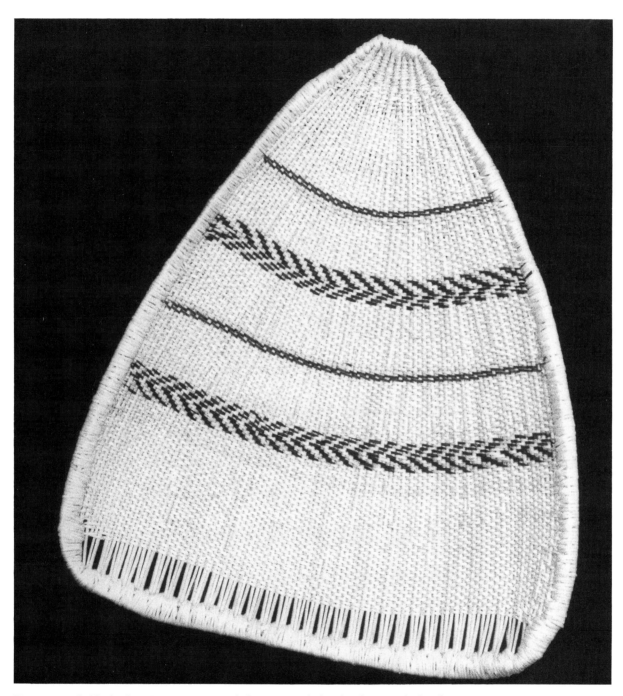

Fig. 17. *Finished basket by JoAnn Martinez with design using the bracken fern root dyed with black mud. The "∨" design is bracken fern root, and the other design is redbud.*

4

THE
BASKETS

Most of today's Indian basket weavers in Nevada remain true to their heritage, although a few have adapted the traditional styles or techniques to nontraditional materials. Styles that were and are important to daily activities—holding babies, keeping money and important papers, winnowing pinenuts, gathering wild onions, gooseberries, and medicinal plants—are the most popular and are produced among all three tribes. Other baskets reflect the maker's intent to carry longtime tradition forward by reviving older styles even though they are seldom used in the old ways. Many baskets are made for the marketplace, and others are made strictly within and for the family.

WEAVING PREPARATION

During the weaving process, the threads need to be kept damp. Many weavers keep a pan of water nearby and continuously dip a hand in the water, then touch the thread to retain just the right dampness. Other weavers keep their threads soaking in the pan. If they are working outdoors and the wind comes up, basket weaving usually stops because the threads dry out too quickly.

To get a uniform size of string, many weavers keep special can lids punched with different sized holes. The willow string is pulled through one of the holes before weaving to even the threads and "make them nice and round," as Theresa Jackson says. She adds that old lids from men's pocket watches are best. She pulls the thread through consecutively smaller holes. Minnie Dick does it a different way: she scrapes the strand carefully with a knife and feels the right size with her fingers as they gently and lovingly move up and down the thread.

Some weavers even the foundation rods in a similar fashion.

TECHNIQUE

Technique must be mentioned briefly, even though this book is not an instruction course. Great Basin tribal people believe the only way to learn to weave a basket is to watch someone do it, preferably someone in your family, and then try it yourself. Taking lessons or reading books is not such a good way to learn to make baskets. It is not necessarily their way. Individual techniques, skills, and styles are meant to stay within the families. This is what makes a strong family tradition, the People say. This is why baskets are still being made.

Two general techniques are used in the weaving of baskets.

Twining is accomplished with two or more weaving (weft) threads that are pulled and given a half-twist between strong rods laid out in a row, one after the other. This is considered by many anthropologists to be the oldest technique in the region.

The *plain twining* technique (see figure 18) creates an even spacing between rods and results in a basket that is rigid and strong, well suited for hard uses, like winnowing nuts and carrying heavy loads. Plain twining is the most frequently used twining technique.

Fig. 18. *Example of plain twining.*

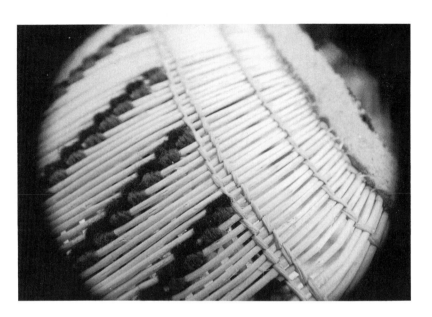

Fig. 19. *Example of diagonal twining (light-colored rows).*

In *diagonal twining*, also called twill twining, alternating rods or pairs of rods in succeeding rows are twined (see figure 19). Although this technique does not produce as strong a basket as straight twining does, the design and weave texture add visual interest to the basket. Many cradleboard hoods are woven with the diagonal twining technique. In the hoods illustrated in this book, the twining is done so perfectly around the horizontal rods and with materials prepared so evenly that your eye almost can't see the diagonal twining technique.

The other technique, *coiling* (see figure 20), is used in the many beautiful round baskets being produced across Nevada today. Here, a willow thread is wrapped around a foundation (usually willow) and stitched into or wrapped around the previous row, spiraling upward. Instead of a needle, the weaver pushes an awl into the coil foundation to make a space to pull the thread through. Many fine basket weavers in the past stitched baskets in this method around a foundation of three rods, in order to control the shape of each coiled row in the basket completely and perfectly. For the three-rod baskets, the weaver makes a hole in the foundation willow and sews through it. Today Bernadine DeLorme, Rebecca Eagle, and Florine Conway are three weavers who are reviving this difficult three-rod technique; Emma Bobb combines two and three stick rods in a foundation, in what is sometimes called the "old Reese River style."[1]

Fig. 20, top. *Example of coiled weave. This will be a water basket, so the coil is packed tightly.*

Fig. 21, bottom. *Two of Norm DeLorme's baskets made with a type of coil stitch, called "gap," to facilitate beading at a later time.*

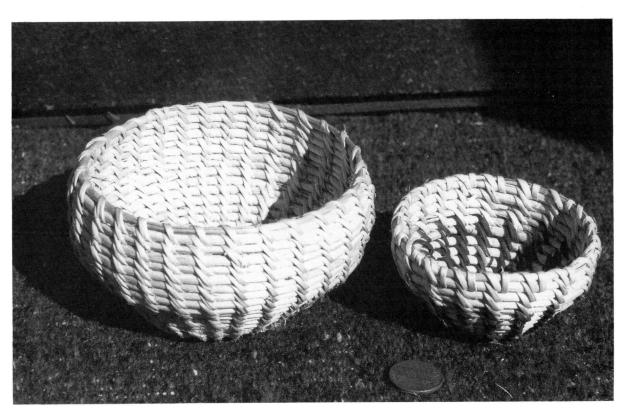

The basket starts, or beginnings, vary as style and tradition dictate. You will occasionally see on a basket today the weaver's "signature"—perhaps a certain shape, type of stitch, or a single tiny bead in a certain color—attached at the center base of the basket, the place of beginning. Look for it!

FRAME OF MIND

Technique, important as it is to the beauty and long life of the baskets (and they last for many generations), is only part of the process. The other important part is the weaver's frame of mind. As the women weave, they often think about times past, about the people who influenced them to weave. And, say both Florine Conway and Lilly Sanchez, "You have to be in the right kind of mood to make a basket." Norma Smokey elaborates: "I was real impatient and my willows just kept breaking. I knew I wasn't in the right frame of mind."

JoAnn Martinez says, "It seems so natural. It gives you a good feeling. I see my mother's hand in a lot of the things I do. And patience!" She laughs. "We have a saying: If you didn't have it before you started, you certainly will before you're finished!" Many weavers agree with JoAnn's added caution: "You can't afford to get mad, because it will show in your basket."

Fig. 22, left. *Detail of a twined-square basket start for a new burden basket by Evelyn Pete.*

Fig. 23, right. *Detail of Evelyn Pete's coiled basket starts for oval and round baskets.*

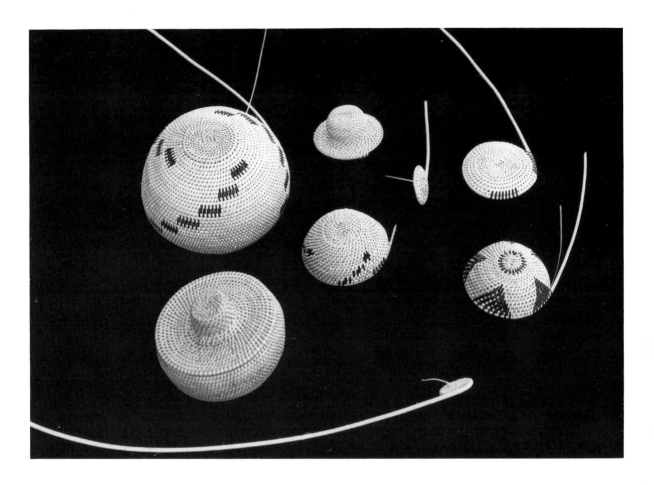

CRADLEBASKETS

Although often called cradleboards, these have no boards in them; the term most often used by the weavers is "cradlebaskets," or "baby baskets." These baskets are growing more popular each year—and for good reason!

Today's cradlebaskets are as strong as those in the old days, when they protected against a harsh environment. Bundled up safely, the baby forgets to cry and enjoys the world while protected both psychically and spiritually. Minnie Dick remembers that her son Leland just loved his. She smiles. "Even when he was walking he would go get his basket and climb over it." Many of the weavers laugh over similar experiences with toddlers who blissfully nap in their cradlebaskets, their long legs hanging out the end, small children who hang on to their cradlebaskets much

Fig. 24. *Selection of baskets and basket starts by Florine Conway.*

25

Fig. 25. *Cody Quartz holding the Avis Dunn cradlebasket that he slept in as a baby. He proudly carried it in the cradlebasket contest at the Pinenut Festival in Schurz, Nevada.*

like a security blanket, or grown children who still like to see their cradlebaskets hanging on a nearby wall.

The weavers agree that cradlebaskets are safer than conventional baby carriers because the hood protects the baby's face against everything from unexpected blows to harsh weather conditions. According to the *Native Nevadan*, there are documented cases of babies being dragged off in their cradleboards by wild animals and remaining unharmed.[2]

Being bound closely, arms down, seems to comfort the babies. I have never seen a baby in a cradlebasket cry. JoAnn Martinez says, "They won't sleep in a crib or a bed when they get used to the basket."

Not only are babies safely bound in their baskets, but they go everywhere and are never left alone. Minnie Dick used to attach a strap on the back of her basket frame and would hang the cradlebasket on a nearby tree or on her back as she worked. Her baby, strapped securely inside, slept blissfully on or watched the world.

Traditions

There are many tribal traditions involving the making and use of cradlebaskets. Frequently, a temporary cradlebasket is made for newborns until

they're four to six months old; then the baby is ready for a regular cradle-basket. The Washoe, say JoAnn and her sister, Theresa Jackson, don't make a basket until after the baby is born and would rather wait two weeks. This is in case something goes wrong before birth. And they don't put a new baby in an old basket. Evelyn Pete, a Shoshone, says, "A lady asked me to make a cradlebasket. I said, 'Wait until it's here.' That's our belief." The Paiutes also believe that to prepare a baby basket before a birth would cause bad luck.

Sometimes the boat-type style is made today, especially as a temporary basket for newborns. Sophie Allison says she copied one that Evelyn Pete brought from Ibepah; now she makes them in a variety of sizes.

The second basket, made after the baby can hold its head up, may be an interim basket as the baby grows; but most often it is the last basket made. (Today, with constraints on the weaver's time and availability of materials, it is frequently the only basket made.) This basket is larger and has a shade.

There are differences among the three tribal styles and sometimes differences in design even within the same tribe.

The Washoe style does not have a frame, as do Paiute and Shoshone baskets. It is just the basket itself, with two or three short braces. Often there are more twined rows on the back part. Neither does it have a buck-

Fig. 26. *A newborn boat-type cradlebasket by Lilly Sanchez near a creek at Duckwater, Nevada.*

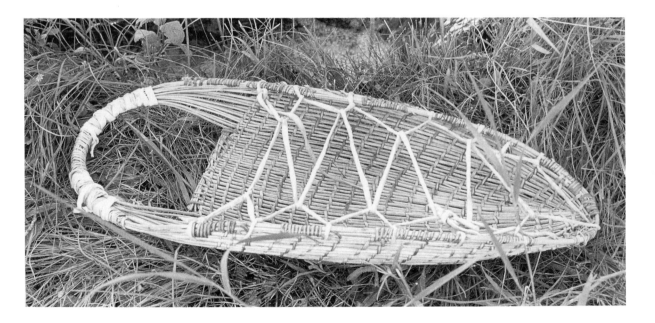

skin or canvas covering. The lacing, which can be a tanned hide or some sort of rag strips, is attached directly to the back.

An interesting difference in many Shoshone cradlebaskets is that the back willow sticks are often arranged horizontally instead of vertically. Theresa Temoke believes this is because the willow "gives" better when the baby lies on it. And the covering in a Shoshone basket is often of good, strong canvas, a practical replacement for buckskin. (Many people consider buckskin too hot for the baby during the summer.) There may also be fringe in the back. Shoshone hood panels are attached to the outside of the basket.

Paiute weaver Robert Baker Jr. says the Paiute hoods, or shades, are attached differently and are "more straight up and down." (The hood side panels are attached on the inside, as are the Washoe hoods). Paiute cradlebaskets are often adorned with bright colors, a result of the influence of the Umatilla and Yakima Indian tribes of Oregon and Washington, according to Norm DeLorme. The Northern Paiute tribes were forced to

Fig. 27, left. *Cradlebasket frames made by Shoshone Minnie Dick are attached to a board while wet and then held in the proper shape until they dry.*

Fig. 28, right. *Paiute Arthur Dunn standing beside bundles of willow and holding a cradlebasket frame, which he has formed with his hands by going around the willow until it is warm and flexible enough to shape.*

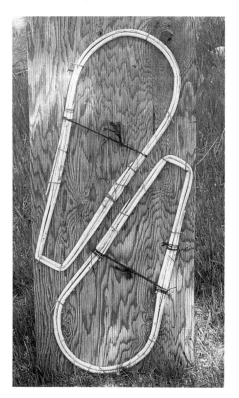

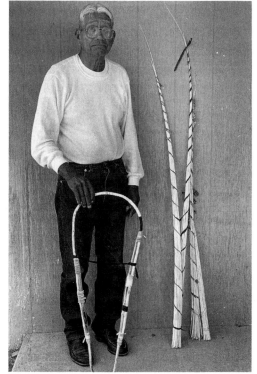

Fig. 29, top. *Shoshone cradlebasket back by Theresa Temoke. Note the horizontal rods and canvas cover.*

Fig. 30, bottom. *Detail of the fringed back of a cradlebasket by Theresa Temoke.*

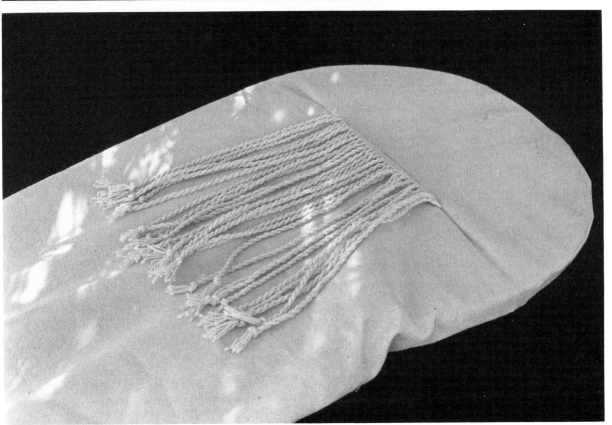

29

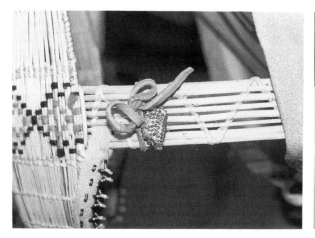

Fig. 31, left. *Detail of Cody Quartz's cradlebasket by Avis Dunn. Note the small-beaded bag tied with buckskin thong, which contains the baby's umbilical cord and is considered "good medicine."*

Fig. 32, right. *Irene Cline displays her beaded containers used for holding a baby's umbilical cord.*

move to these areas in what could be called a Paiute "Trail of Tears" after the Paiute Wars and other activities in the 1800s.[3] Mr. DeLorme says the influence of those areas is seen in the beautiful buckskin, beaded designs, and fringe work.[4]

In keeping with the Paiute belief that objects created from mother earth must be treated in a respectful way, and also for spiritual support, the baby's navel cord is placed in a tiny beaded buckskin pouch and hung from the cradleboard.[5] The pouch is considered good medicine—a good luck charm. Unfortunately, gamblers often steal it, hoping it will bring them good luck.[6]

Washoe people tied the baby's umbilical cord pouch to the cradlebasket and included a lock of the baby's hair. It was tied on the right side of the hood, so the baby would be right-handed.

Lilly Sanchez says, "Shoshones don't believe this way. Generally I've been told to take it [the dried cord] up to the mountains, pray with it, then put it in a pack rat's hole. They will take care of it, because they [the pack rats] are not lazy, but are hard workers." Mrs. Sanchez adds, "Whatever you do, don't lose it [the cord]." She was told by her elders that if this happens the child will become lost, always looking for something in its adult life—"always looking for their cord."[7]

You can tell the sex of the baby by looking at the hood. Diagonal lines of colored yarn across the top indicate a boy, while diamonds or touching lines are for a girl.

There is an Indian heritage bonding effect, too, according to Gary Bowen, health clinic director. In a cradlebasket, an infant bonds with his

or her heritage in a psychological sense, similar to the newborn-mother bonding that is so important. "Plus the added factor of pride and curiosity when the child reaches the age when he realizes he was in that cradleboard as a baby," Bowen adds.[8]

> Cradleboard
> Tan, buckskin
> Rocking, holding, caring
> A little Indian child
> Basket.
> —Morning Manning[9]

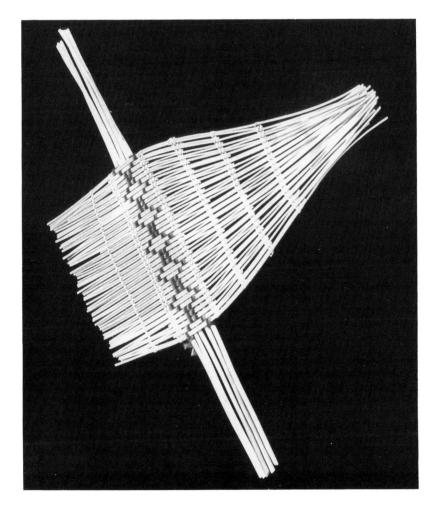

Fig. 33. *Washoe cradlebasket hood by Sue Coleman.*

Sue Coleman has started making cradlebaskets. She says the hood is one of the most difficult things to do. "If you break something, you have to start all over again. You can't repair it." She starts with the design first. Her miniature hoods have 100 willows in them and the big ones can have up to 350 willows. She tells her cousin Norma Smokey, who is sitting nearby: "Be careful when you bend the hood over into a curve. Do it gently or it might break!" This beautiful part is curved as it is being woven, and if done the right way, it curves into a beautiful, natural-appearing shape.

WINNOWING BASKETS

The winnowing basket, or winnowing tray, continues to be needed as long as there are pinenuts available in the Great Basin for Indian people to harvest.

The pinenut is a fat little shelled nut that grows in the pineapple-shaped, ocher-colored cones of the piñon tree, found in mountains of the Great Basin. More than any other food, the pinenut provided all of the Native people of the area with the protein and calories necessary to survive the cold winters.[10] Imagine how they suffered during the white invasion, when piñon trees were cut by the thousands for firewood and houses! Today, although many of the traditional pinenut areas are privately owned, the People continue to search for places for their annual fall pinenut harvest.

When the air becomes crisp, the rose hips of the wild rose bush turn red, the rabbitbrush bursts into yellow blooms in the mountains, and canyons shine with the autumn yellows and reds of the quaking aspen, it's pinenut time!

Fig. 34. *A pinenut cone on a piñon pine tree near Austin, Nevada.*

> When we come to the pinenut place we
> talk to the ground and mountain and ask everything.
> We ask to feel good and strong.
> We ask for cool breezes, to sleep at night.
> The pinenuts belong to the mountain,
> So we ask the mountain for some of its pinenuts
> to take home and eat.
> —Traditional Paiute Pinenut Prayer[11]

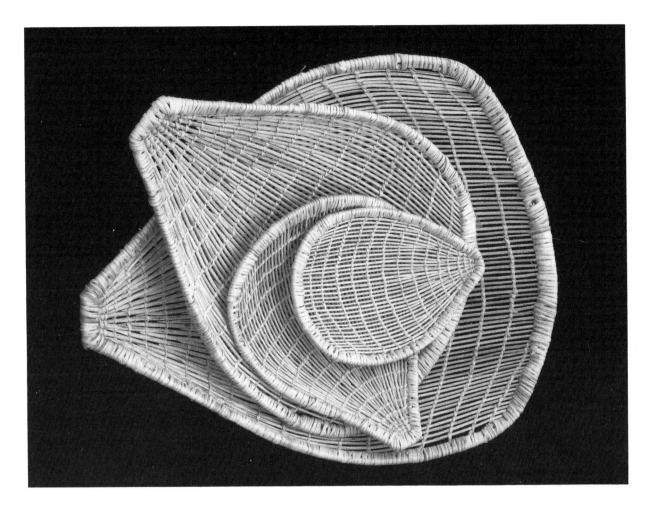

The winnowing basket almost calls out for memories—large families camping at favorite pinenut grounds, knocking the cones out of the trees with poles, tossing them into the burden baskets, shaking cones and nuts down onto a tarp laid beneath the trees, with hands covered with dust or gloves to avoid the sticky pitch. The green cones can be buried overnight in sage and hot coals; in the evenings the pinenuts are cleaned. There is much laughing and joking. Old people tell stories around the camp-fire and everyone sleeps close together. These memories could be from a hundred years ago or just last fall.

Roasting pinenuts in a winnowing basket takes a practiced hand. Many of the women laugh as they describe their first experience and burning

Fig. 35. *Nest of winnowing trays by Sophie Allison.*

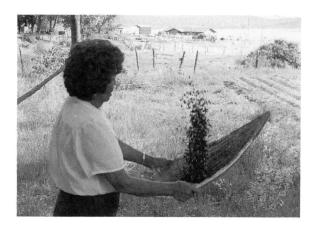

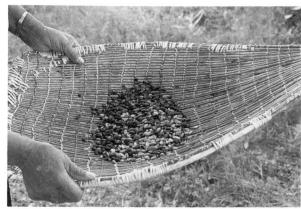

Fig. 36, left. *Evelyn Pete tossing the pinenuts in her winnowing basket in order to separate the good nuts from waste materials and rotten nuts.*

Fig. 37, right. *Evelyn Pete holding one of her winnowing baskets with pinenuts in it.*

their baskets! First the pinenuts are placed in the basket and then some hot coals are shoveled in. Immediately the shaking begins: tossing and turning the nuts and coals together in a constant rhythmic motion so the basket will not be burned. Minnie Dick says you have to keep the hot coals on top of the pinenuts so they won't burn the basket. When the nuts begin to pop, that means they are cooked; they are quickly separated with the shakes of experience and then tossed out. Much of the charcoal will drop through. The nuts are then cracked with a mano and metate, as in the old days, with a rolling pin and breadboard, or by any method that works. Then they're returned once more to the winnowing tray to begin another awesome process: the still moist and heavy nuts are separated from the shells and the shells are tossed out. This winnowing is done in a motion that seems to be as smooth and familiar as a smile. Only one piece of help is needed: a breeze must come along and blow the shells away. And it does!

A winnowing basket is always woven with its function clearly in mind. Some are spaced for cleaning, so the dirt and needles will fall through. Some are spaced farther apart for cooking the pinenuts in live coals. Sophie Allison made a tightly woven basket that her Shoshone people once used for catching the little sunflower seeds. "The bad one flew away," she explains, meaning the debris, dust, or impurities.

JoAnn Martinez recently made a tightly woven winnowing basket using the bracken fern root she had dyed. "Like my mama used to make," she says. It is used to sift flour. After the pinenuts are pounded into flour,

Fig. 38, top. *Pinenuts lodged between the rods of a winnowing basket.*

Fig. 39, bottom. *Tightly woven winnowing tray by Sophie Allison. The subtle design is created with darker willow.*

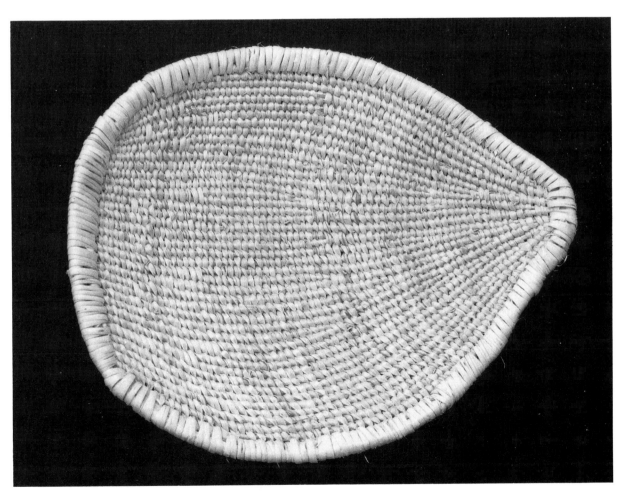

JoAnn says, there are still impurities in it. "You shake it in the winnowing tray to get those impurities out." JoAnn says the flour stays in the basket and is brushed into a bowl, often using a soaproot brush.

Norma Smokey chose the winnowing basket as her first basket to make. She dreamed about making one and has many memories of camping as a young girl with her aunt Frieda Wyatt at pinenut time. Aunt Frieda always used winnowing trays. Norma remembers her dad would bring them water every two days. They slept out in the fresh air, and Norma said the smell of fried potatoes and onions still brings back the memories of "pinenutting" with her aunt. Norma will give away her first basket, as tradition dictates; she listens to her aunt Theresa Jackson say, "Pick out the willows and get 'em all even. Size them out and use all the same size." Norma holds the willows in a fan shape as she weaves, then lifts them to her nose, drinking in the willow fragrance. "Mmmmm."

Norma is happy to be learning more of the culture from her aunts. She

Fig. 40. *This work in progress is the first winnowing basket ever made by Norma Smokey.*

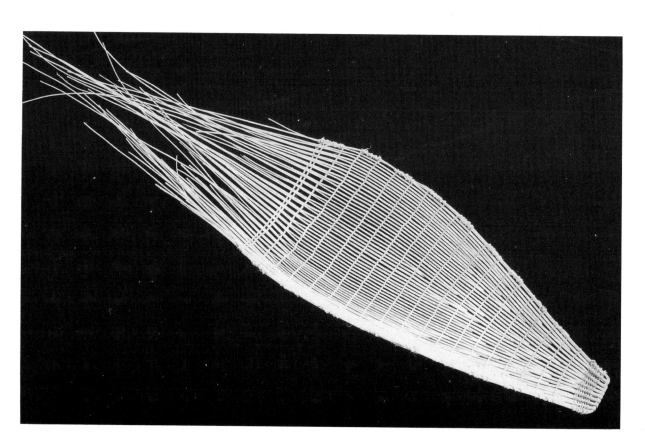

drives them to some of the good willow places and they show her the ways of the willow.

She is telling us all of this during an interview. As they sit at the table behind the Dresslerville Senior Center working on their baskets, their most intimate time together begins. After Norma's story about pine-nut time, Theresa talks about the medicine plants around. She and sister JoAnn, remembering old times, tell about the six o'clock curfew when Indians had to be out of town; JoAnn, a small girl, ran home hanging on to her grandmother's hand. All Indians had to be out of town by sunset, they say. They talk about the girls' puberty ceremony, still performed by Washoe people from time to time, and Norma wishes she could speak her beautiful Washoe language. But she and most Native Americans in the Great Basin were taken from their homes and enrolled at the Stewart Indian School, where tribal languages were forbidden. They smile about it now, though. "I rebelled," JoAnn laughs. "I was always in trouble!" Norma says, "And where she left off, I picked up!" JoAnn talks about marching in military formation, rising and going to bed by a bell, and the thing everyone at Stewart did at one time or another: running away. JoAnn says there were hardships but their people "made do." She adds, "Our family has always had to stand up for what we believe. It [the right feeling] has to be right here." She touches her heart.

With one row woven across to the left and one return row of a winnowing basket we learn more about the times and culture of these beautiful and brilliant women's lives than we ever heard before. We feel pulled into them, we see them more clearly now.

That's part of the beauty of basket weaving. Part of the reason the tradition continues.

Washoe Creation Story

The Maker of All Things was counting out seeds that were to become the different tribes. He counted them out on a big winnowing tray in equal numbers. West Wind, the mischievous wind, watched until the Maker had divided the seeds into equal piles on the basket. Then he blew a gust of wind that scattered the seeds to the east. Most of the seeds that were to have been the Washoe people were blown away. That is why the Washoe are fewer in number than other tribes.[12]

ROUND BASKETS

This style has become a popular style to market, and basket weavers in the Great Basin make these baskets by the coiled method. Many of the weavers make miniatures, and the baskets often have designs in devil's claw or redbud or other embellishments or are covered with beads in a bright and beautiful way, using the patterns of their ancestors. No two ever seem to be alike, and each weaver has a distinct and personal style.

Theresa Jackson says gray willow is best for round baskets; it's more uniform when you split it, and if you get them long you don't have to add so much. "You have to have real good thread for round baskets. Split it, then whittle it down, then run it through can lids to make them [the threads] nice and round."

BURDEN OR CONE BASKETS

Fig. 41. *This round basket by Florine Conway is a diagonal interpretation of traditional Washoe patterns.*

The burden basket was once the mainstay of traveling tribal people, because it was designed to balance large loads evenly. A large cone basket

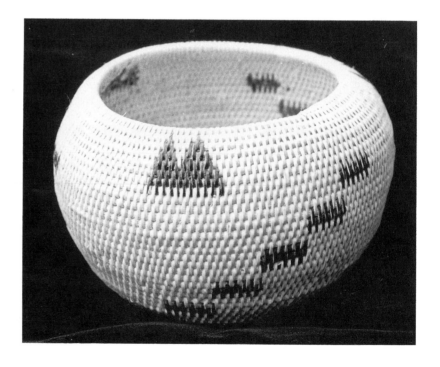

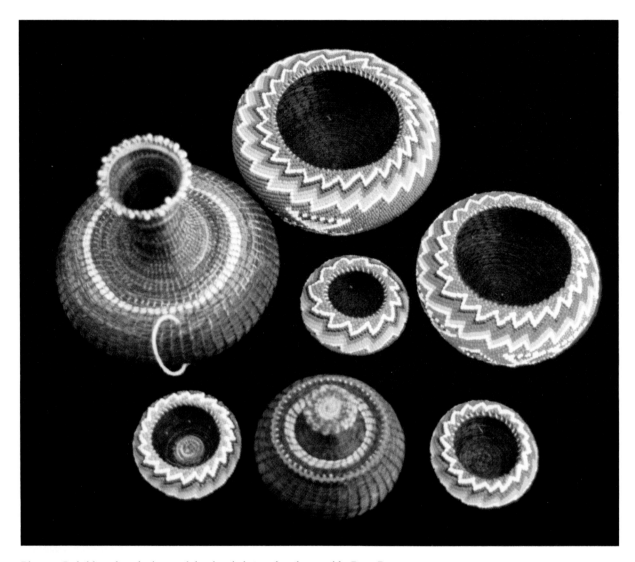

Plate 1. *Coiled horsehair baskets with beadwork designed and created by Betty Rogers.*

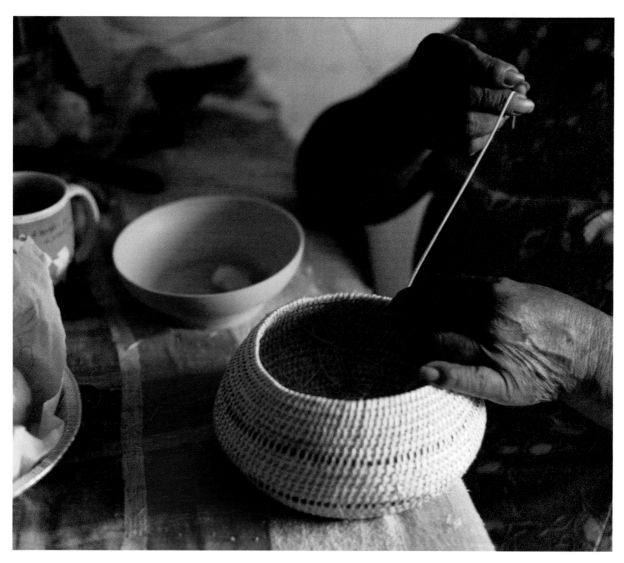

Plate 2. *Emma Bobb pulling a willow string through a row of her coiled basket;
the subtle color stripe in the basket's center was achieved with wild rose.*

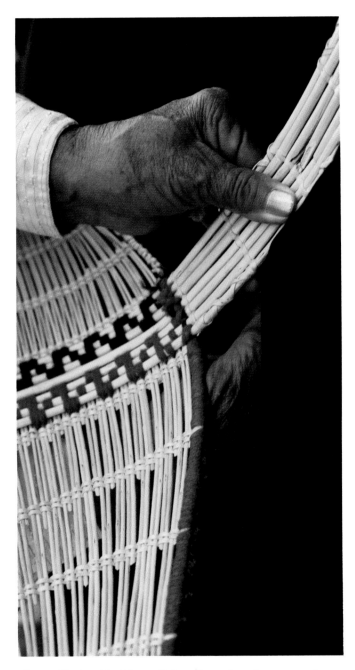

Plate 3. *Washoe elder Theresa Jackson shows where she must repair a cradleboard hood because the environmentally weakened willow has been broken.*

Plate 4. *Florine Conway and her award-winning Washoe baskets at the Wa She Shu Edeh Festival in Tallac, Nevada.*

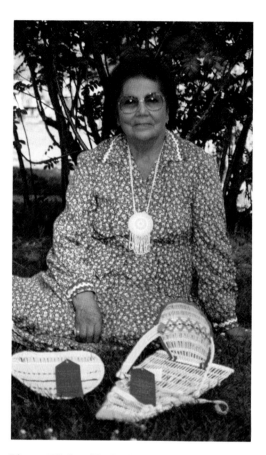

Plate 5. *Washoe elder Jo Ann Martinez received blue ribbons for her winnowing basket. Left: Basket woven with bracken fern for the black design. Right: Cradlebasket.*

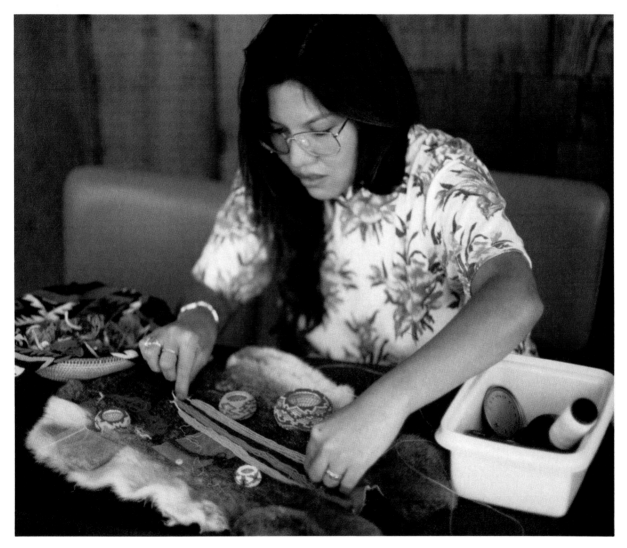

Plate 6. *Rebecca Eagle Lambert, one of Nevada's most prolific weavers, demonstrating at a basket gathering.*

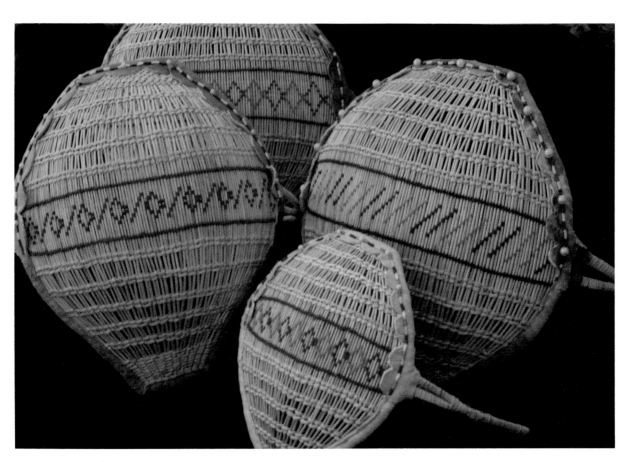

Plate 7. *Cradlebasket hoods edged with soft leather and beads. Touching lines on the hood design indicate a female baby; diagonal lines indicate a male baby.*

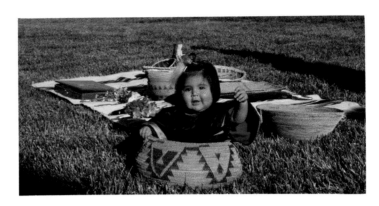

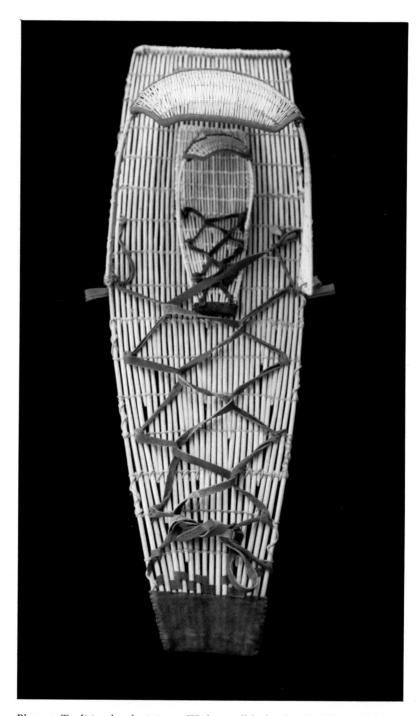

Plate 10. *Traditional and miniature Washoe cradlebaskets by elder Theresa Jackson.*

Plate 11. *The Screaming Eagle Dancers performing the Basket Dance during a spring festival at Stewart.*

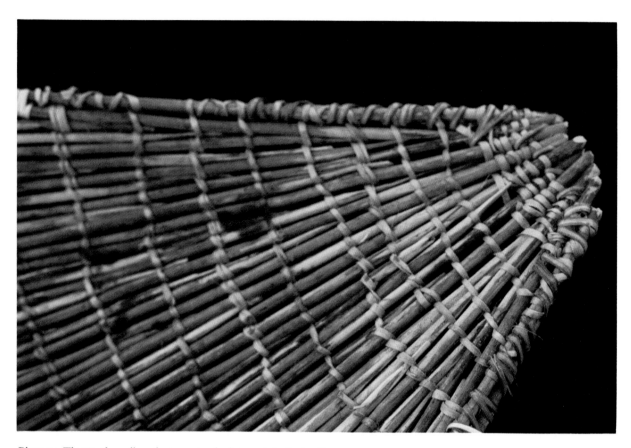

Plate 12. *The tip of a well-used winnowing basket made by Evelyn Pete.*

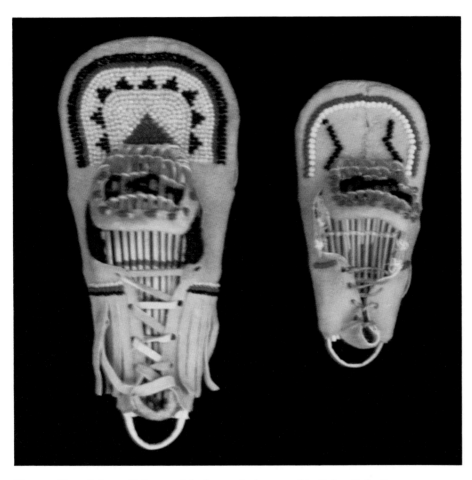

Plate 13. *Two miniature Paiute cradlebaskets perfectly executed by Robert Baker Jr.*

Plate 14. *Boat-type infant cradlebaskets by Sophie Allison, which she identifies as "old style" (top basket) and "new style" (bottom basket).*

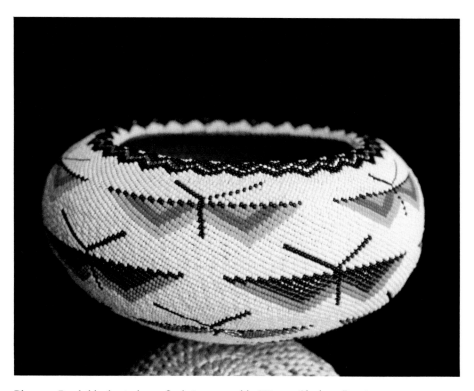

Plate 15. *Beaded basket in butterfly design created by Western Shoshone Bernie DeLorme.*

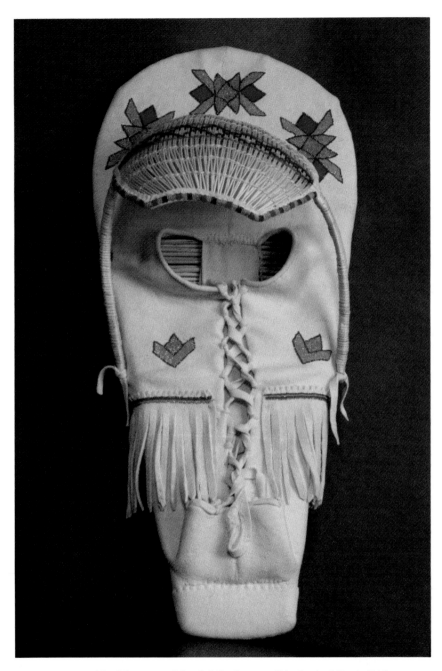

Plate 16. *Unusual buckskin-covered, beaded Shoshone cradlebasket by Minnie Dick. Design was placed to cover a bullethole.*

Plate 17. *Three pine needle baskets coiled in the Washoe technique by Larena Burns.*

Plate 18. *Oren Dubui Sanchez playing Wussa Ya Gind, a shake game Shoshone children still play from time to time. It is played with a small winnowing basket and lightweight chips of willow, mahogany, or apple. One side of each chip is painted white and the other red.*[b]

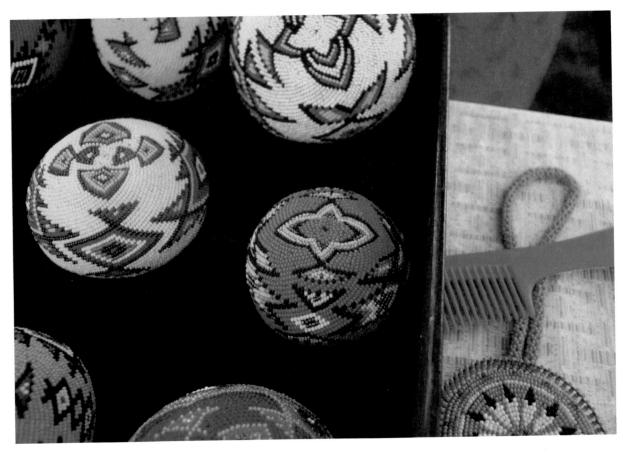

Plate 19. *Irene Cline beaded baskets displayed for sale at the Reno-Sparks Colony's Numaga Indian Days. (Photo copyright © 1995 by Chuck Fulkerson)*

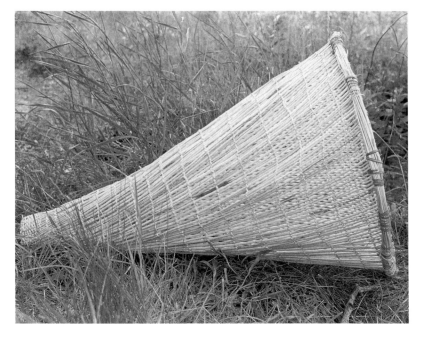

could hold a family's entire household. (Native people did not value the accumulation of unnecessary "things.") Open in weave and lightweight, this basket was the perfect traveler. A temporary burden basket could be made in three to four hours if necessary, and small sizes could be carried easily by children.

Although the burden basket has often been replaced with plastic at pinenut time, there has been a recent revival, led by Lilly Sanchez of Fallon. Lilly and her sister, Evelyn Pete, as well as Sophie Allison, are strong believers in tradition, as demonstrated by their burden baskets, made with strong, straight willows evenly woven. Paiute weaver Cye Hicks also makes burden baskets, using larger, roughly scraped willow and wood and leather bases.

The traditional burden basket woven by Lilly, Evelyn, and Sophie has a double-twine start at the base, using strong willow gathered and prepared in the time-honored way. It is an open twined basket, with extra willow rods added as weaving progresses to expand the diameter of the cone. The twining stops when the desired size has been reached.

Fig. 42, left. *A burden basket by Evelyn Pete rests in the grass near her Duckwater home. Note the upward swirl.*

Fig. 43, right. *The inside view of the bottom of one of Evelyn Pete's burden baskets.*

SEED BEATERS

While this basket style is no longer in use, it once was highly utilitarian, with rods evenly spaced in order to catch the wild grass seeds, which were harvested for food. Grasses were beaten with this handled basket into a fine-woven winnowing tray, held underneath the plant. The seeds were then prepared to eat, according to Lilly Sanchez. Lilly, a Western Shoshone, is reviving this beautiful old style, and Theresa Jackson, who has vast knowledge of useful plants of the Washoe people, recently made a small seed beater and demonstrated its use on a weed growing on the grounds of the Gatekeeper's Museum in Tahoe City, California.

The seed beater is also woven with the twining technique. The willow spokes bunch together at the end, forming a handle, and a sturdy rim adds the strength needed when the basket is beaten against a plant or bush.

Fig. 44. Lilly Sanchez demonstrating the way a seed beater basket (left) is used with a winnowing basket (right).

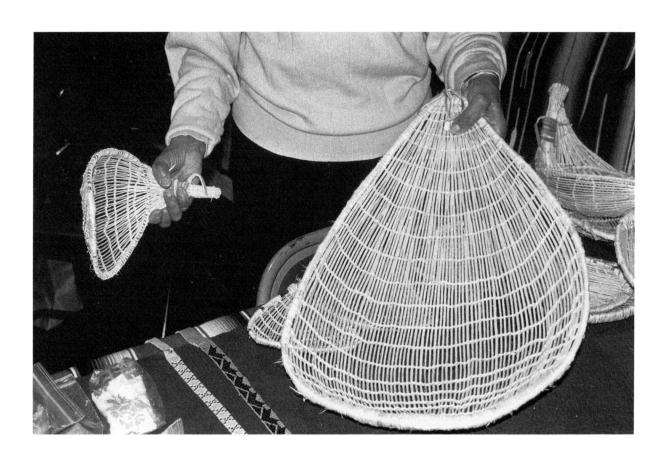

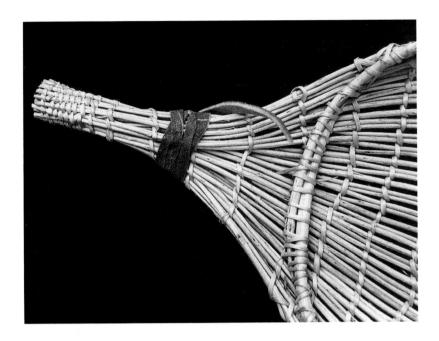

Fig. 45. *Detail of seed-beater basket by Lilly Sanchez.*

WATER BASKETS

We can only imagine the centuries-old amazement and delight that greeted the newly discovered process of covering a tightly woven basket with piñon pitch, thereby making it watertight. In the harsh desert environment, this miracle invention, which combined the two most dependable plants around—willow and piñon—probably changed the way people lived, allowing them more freedom of movement in their search for food as well as their gatherings with other people. The old Paiute-style water jugs also had an ingenious shape—a pointed base, a broad middle, and a small hole at the top. No matter how the jug fell, the water would not spill out. The Shoshone-style jug made by Evelyn Pete is flat on the bottom, much like a vase.

Only three people we interviewed remembered making water baskets; Evelyn Pete made one especially for this publication (see chapter 7).

Minnie Dick says you boil pitch from a piñon tree just like syrup. "Then all the time use cold water in the basket."

Emma Bobb has made these water baskets in the past. First Emma makes the basket with a twill twining technique, taught to her long ago

by her mother. (This technique involves twining over warp rods in a specific alternating rod sequence and seems to be no longer in use.) She then fills it with sand and keeps it damp to flatten the bottom. After it is flat and dry once more, she makes piñon pitch hot in a can, boiled like syrup, and pours it, along with hot rocks, into the basket. "Pour it in and shake it around," she says, "then pour it out." Emma remembers that her family used to carry water in these baskets when going after pinenuts.

THE WEAVERS

TRADITIONAL WEAVERS

Minnie Dick

Respected weaver

We drove across the infinite sagebrush miles and turned abruptly at a small sign that said LEE. As we dipped into a little valley the morning light began to give way to a strong daytime sun, its fullness turning alfalfa fields a bright, blinding kelly green. Or maybe it was the desert contrast that made the color seem so unreal, like fields from a Disney cartoon. A clear, singing creek wound through the thick greenness, and here and there grew lush stands of willow and wild rose. Tall old cottonwoods edged the fields. It seemed to us seasoned desert rats an Eden rising in the Nevada desert.

We drove up the middle fork in the road, following our directions to Mrs. Minnie Dick's home. Willow was everywhere—a Nevada basket-weavers' paradise. (Later we learned that no chemical pesticides are used at Lee, so the river and willow are pure.)

We turned into Minnie's gravel drive and there she was, sitting in beautiful, upright majesty in a straight-back chair under an apple tree, her rifle propped beside her, gazing out over the land. At 89, she had been shooting squirrels. On the table behind her was the pan for cleaning them.

We expected a legend, because Minnie was held in high esteem by many other basket weavers. And as we drove into her place and saw her sitting there, we knew we were looking at one.

English is her second language and comes out with a Shoshone flavor. "I learned by lookin' at my two grammas—my mother's aunts. They always workin' on the willows. I just watch them, and after a while, I can do it."

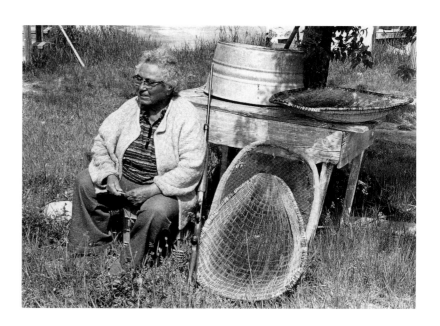

Fig. 46. *Minnie Dick sitting in her yard next to several winnowing baskets she has made and used for roasting and winnowing pinenuts over the years. Note the improvised screen basket behind it.*

Minnie, who is Western Shoshone and part Washoe, was almost 10 years old when she first learned about working willow into baskets. The family was living in tents on Warren Williams's Alpine Ranch near Cold Springs, out of Austin. When that ranch went dry, in about 1914 when she was 10, she moved to Battle Mountain, where her mother's sister lived, and went to school. There were no reservations at that time, Minnie says. Then she moved to Owyhee, where her three children were born, and, at age 48, she moved again, to Lee.

Minnie has had a busy life working and raising her family. She worked as a cook in the school lunchroom at Lee and went to Elko on the bus with her children. In between times she tried to work on the willows and managed to make a baby basket for her son Leland. But finding time was scarce, she says, and "Leland's the only one in my own basket." She smiles, remembering, telling us how he loved it. When she went to town on horseback, she hung her son in his cradlebasket on the saddlehorn, and away they went, Leland rocking peacefully to the horse's gait.

And, finally, "After I retired I started on baskets."

Kind, intelligent eyes smile out from her smooth, burnished skin. Minnie seems pleased at our interest in her baskets and begins to speak about their importance to her. She touches a smooth lidded basket and explains

that this one holds the money in her booth at the Christmas bazaar. Her winnowing trays are very large so she can prepare large quantities of pinenuts, even though she says it is "heavy on your back." A modern version of the winnowing basket has screen material. She is in the process of making two doll cradlebaskets. When I ask her why she keeps making baskets, she says simply, "Because people keep on asking."

She gives her words for the baskets: both the burden basket and the winnowing tray she calls *y'andu*; she says the cradlebasket is called *gono*.

I ask her how a person could learn to make baskets. This is an inconceivable question to her, and to many of the other weavers. "Nobody teach me how," she says. "I just knew by looking, and then trying it." Gineice Carter, a young friend and helper, adds, "It's just *in* her." Gineice is trying to learn to split willow and went with Minnie on a recent pinenut gathering trip.

Fig. 47. *Minnie Dick holding a lidded oval basket that she has made.*

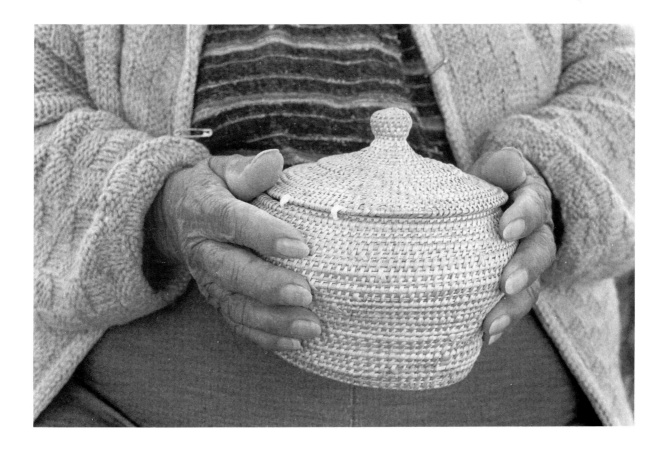

45

Minnie says a young girl must learn from the old people. "And when you learn, learn how they used to do it."

She says she gathers willow where there's not much water. If it grows by the water, it's brittle. She splits it when fresh, coils it into bundles, and completely wraps the coils to keep the willow white. When she makes her strings she throws away the core and saves the bark for rough work. She scrapes each piece, one at a time, with a special willow knife to get the peel off. She scrapes the edges of her string too, to make them rounded and soft. She weaves in the twining technique from left to right, then turns the work "upside down" and weaves back. She uses her right hand and weaves just one way, a style that is hers.

Minnie can also make round coiled baskets with lids that fit smoothly, an art she learned by watching someone else make them. She keeps her bowl of water, pliers, knife, and strings nearby. (The pliers will pull the

Fig. 48, left. *Minnie Dick holding the hood for a cradlebasket on which she is working.*

Fig. 49, right. *Arthur Dunn and Avis Dunn holding a cradlebasket without the hood.*

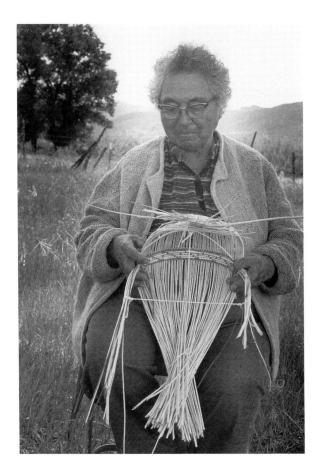

strings through the coiled rows.) She also has an added piece of equipment to even up her willow strings—an old starter from a car.

Gineice says, "She does it perfect, so it will last forever. It couldn't be done any better than she does it."

The winter she was 89, Minnie made three winnowing trays. The preceding fall she had won an award at the Schurz Pinenut Festival's Cradleboard contest (she was also on the winning gambling team at that festival!). She has just completed a cradlebasket that Mrs. Lisa Shurtz of Elko commissioned. It has taken her nearly three years to find a perfect hide for the cover, and she tanned it herself. The beadwork is Minnie's own design, and she says she used lavender-colored flowers to disguise the bullet hole.

Minnie received a grant from the state of Idaho Folklife Division to go to Owyhee, on the Nevada/Idaho border. She lived there for two months, teaching girls how to make cradlebaskets and shades and winnowing baskets. They had no elders to teach them, but they remembered that their grammas got willows at the river. Minnie says they tried to learn to split willow but used chopping blocks to start. "If they keep it up, they'll learn." Nine people started her class and she was happy that five finished.

People interested in Minnie's life and style may see her on video, available at the Northeastern Nevada Museum in Elko.

For a lifetime of excellence in basketry, Minnie Dick received the State of Nevada Governor's Arts Award for Excellence in the Arts in 1988.

Avis Mauwee Dunn and Arthur "Long Tom" Dunn
Partners

We find Avis Dunn and her husband, Arthur (affectionately known by friends as "Long Tom"), waiting for us in their home at Nixon, set near the sandy shores of beautiful Pyramid Lake, headquarters of the Pyramid Lake Paiute Tribe. The Dunns' ten-year-old grandson, Andy, just home from school that day, reads magazines and listens, interested in what his grandparents have to say.

We knew early on, after seeing the Cradleboard Contest at the Schurz Pinenut Festival back in 1991, that we would have to find Avis Dunn. In the "Cradleboards without Babies" category, all three prizes—first, second, and third place—were awarded to cradlebaskets made by Avis Dunn.

Fig. 50. *Arthur Dunn holding a hide that he has been working.*

And beauties they were. Avis's exquisitely twined and shaped willow cradlebaskets were combined with intricate beadwork in colorful pictorial and patterned designs atop soft buckskin meticulously prepared by her and Arthur. We had seen these intricate designs and soft, golden buckskin only in older cradlebaskets, and we wanted to meet these artists.

Today, as with all of our meetings with Native artisans, we are deeply impressed. Avis has a lot to say about their work, and they are proud to be contributors to their heritage. Their home is warm and friendly—the TV going, willows bunched at the back door, a table near a window corner at the end of the little kitchen all set up with beads, a lamp, and work in progress. Through the window we have a spectacular view. White pelicans fly in formation against water and sky on their way to Anaho Island, a national pelican refuge.

The Pyramid Lake area has become extremely dry in recent years, and willows are not plentiful or always good. Arthur goes up a special canyon near Cedarville, California, to get their material. He gets chokecherry and red willow for frames and makes the tough wood warm enough in his hands so that it will bend; then they tie it to hold the shape until it dries.

Avis says they used to have an Old Ladies' Club at Nixon, where the ladies would bring their sewing and weaving. "I'd watch them. I would ask questions and they'd tell me. One old lady showed me when they were picking willows where the good ones were." Avis says they taught her to look for four different kinds: one for the top, one for the sides and arms, one for the bed, and one to split to weave with. "They showed us how to split. You go from the tip and bite, putting one in your mouth and two in your hands, then split down. I can't do it, only with the straighter and taller ones."

Avis now gets her strings from a lady in Fallon. She peels the skin off, prepares the strings, and weaves the hood and the inside willow mat for the baby to lie on. Arthur makes the frame for the cradleboard.

Arthur scrapes and tans the deer hide. First he soaks the hide in water so the hair will fall off. Then he hangs the hide over a special smooth pole—smooth because he has used it for fifty years for the same purpose. Next Arthur scrapes the hair off and soaks the hide in brains overnight.

At this point, I wrinkle my nose and say, "Ugh—I bet that smells!" Avis laughs and says her children used to say, "Mom and her stinking

hide!" to which she would retort, "The money don't stink!"

The hide needs to be stretched so it won't dry out too fast; Avis helps Arthur pull, squeeze, and stretch until the hide is dry. I'm sure my mouth is wide open, thinking of all this physical exertion by two Paiute elders—Avis had to arrange our interview around twice-weekly dialysis treatments!

After the hide is completely dry, it is time to smoke it to the beautiful golden-tan color found on only the most special Paiute cradlebaskets. This part is done by Avis; her sister, Lena Wright, taught her the process. She uses the Dunns' former home in Nixon for this. When the People moved into HUD (federal Housing and Urban Development) homes years ago, all the old homes, Avis says, were mowed down. All except theirs, for some reason, and this became their smokehouse.

First Avis makes the hide into a sort of cylinder bag, turns it inside out and hangs it. She attaches a skirt to the bottom, fits this over a smoking fire bucket, and secures it with a pant leg wrapped around the bucket. Now she watches it very carefully, for ten to fifteen minutes of smoking, until it's just the right color. The resulting hide is so strong, Avis says, that "you can hang it on a barbed wire fence and it will never hurt you." In fact, they make sturdy gloves and moccasins from their hide in addition to the cradlebasket covers.

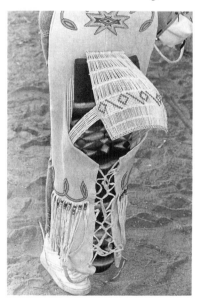

Fig. 51. *An Avis Dunn cradlebasket with a traditional beadwork design.*

To make this cover, after the basket frame is made, Arthur puts willow crossbars across the frame, then lays the willow mat on the crossbars. The hide is pulled over it and cut down the middle so it fits across. Then Avis cuts around where the head will go. Avis likes to cover the sides of the shade (hood) with satin so it won't scratch the baby. She estimates that if all goes right it takes them about two weeks to make a baby basket (*hupe*), including the hood, with the help of her daughter. Beads and fringes are added for decoration. Sometimes people ask for certain colors and designs.

I exclaim over the color in Andy's cradlebasket, which is hanging nearby, and Avis said Myrna Dunn, their youngest daughter, did the design and beadwork. "She's always got to have orange," Avis says. Avis herself is partial to dark and light blues. She says she makes up design ideas in her head, sometimes from something she sees somewhere.

Her niece is starting a basket. "She wanted to know how to cut the

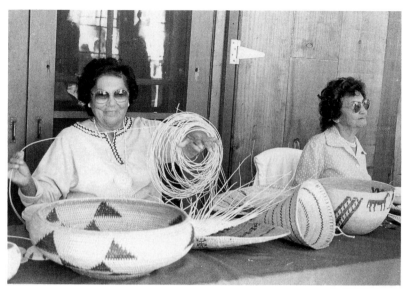

Fig. 52, left. *Theresa Jackson (left) and JoAnn Martinez (right) standing in the doorway of a traditional summer shelter made of willow.*

Fig. 53, right. *JoAnn Martinez and Theresa Jackson demonstrating their basketmaking skills at Tallac, south shore of Lake Tahoe, California.*

hide and I showed her. And how the top is partly bended. That was quite a while ago. The other day I asked her, 'How you comin' along with the basket?' and she said, 'Slow!' Ha! Ha!"

We left the Dunns' home feeling we could have stayed for days and learned something new every minute.

Theresa Smokey Jackson and JoAnn Smokey Martinez
Washoe elders

We spent many hours in the beautiful backyard of the Dresslerville Senior Center, sitting around a picnic table under rustling trees, listening to Theresa and JoAnn tell us about their traditions. Once we went to Theresa's home and, standing near a profusion of flowers and plants, saw her mother's grinding stone, found by her brother and delivered to her in his backhoe. Once at JoAnn's home we photographed her bracken fern dyeing process and met her little dog, Hemu (the Washoe word for willow). Dresslerville is a small (40 acres) Washoe colony near Gardnerville. It was donated to the Washoe in 1917 by a Carson Valley rancher.[1] "We had no home of our own," said JoAnn. Residents are restricted to living on small plots on the slopes of ranges they used to wander at will. But all

the bad experiences disappear when the sisters speak of their rich culture.

JoAnn inherited her grandfather's storytelling ability and, in her musical, hypnotic voice, she does much of the explaining. Describing her grandfather, she says the children would all get into bed and cover up each evening, and he would tell stories until they fell asleep. They could hardly wait to go to bed the next night to hear the rest of the story. We feel the same way—we can hardly wait to return to Dresslerville to hear JoAnn's stories. Especially the one about the old grandmother and the willow thread, which you will read by and by.

Theresa is the family spiritual counselor; because of her spiritual abilities she was asked to write and deliver a prayer at the annual Nevada Governor's Breakfast in 1991.

"She [Theresa] is the mentor for me," says JoAnn, "a very spiritual person with a lot of wisdom. And now that she is the oldest member of our family, she is the matriarch of the Smokey family. We honor her as such."

Theresa tells about the Washoe girls' puberty ceremony, still being celebrated from time to time, in which a basket plays an important role (described in chapter 8). In addition, she has vast knowledge of the plants that generations of her people used for food and medicine, and she was a contributor to development of the Washoe Demonstration Garden at the Tallac Museum at Lake Tahoe. The Washoe view plants and trees as gifts of the land, traditionally gathered by Native women who were expert botanists.[2]

While JoAnn and Theresa are two distinctly separate individuals, when it comes to willows, basketry, and other Washoe traditions, they converge and speak as a family of many. They tell of their mother, grandmother, sisters, nieces; they bring out their mother's and both grandmothers' baskets from an extensive collection; they know the uses of each and describe them. There are two exquisite finely woven winnowing trays made by their grandmother Mendy (Washoe name "Ogie") Smokey, one for pine-nuts for soup and one for processing acorns; grinding acorns into flour and the preparation of acorn soup and acorn biscuits were other parts of our introduction.

JoAnn and Theresa want us to know that the basket tradition didn't begin with them. It came from countless generations of a people who belonged to the land and knew its rhythms.

"We lived a healthy life," says JoAnn. "We lived outdoors and did a lot of walking and physical work. The water was always clean and pure. We gathered food and materials and offered prayers at times of celebration. We had the wind to sing us a song, the sun and moon to guide us, and the energy of the earth beneath our feet. We knew about the harmony and interdependence of all living things. We're close to the land, that's all we had. In order to live, you had to respect what it produced for you and take care of it. It was a sacred gift to share and preserve for future generations. The elders would teach moral values and principles through stories and songs. And we learned to accept people as they are. If they don't like you, leave them alone."

Their mother, Sadie Joe Smokey, had ten children. She made baby baskets for them all and for her grandchildren. An accomplished weaver, she gave her gift to her daughter Frieda, who has since passed away. Another sister, Lucille Morris, learned some techniques from a teacher at Stewart Indian School and collects baskets.

"Weaving a basket seems so natural," says JoAnn. "It gives you a good feeling. You relate to it. We were taught to enjoy what you do with your hands." She adds, "I see my mother's hand in a lot of the things I do. When I weave across I go left, even though I'm not left-handed. It seems natural. I've seen my mama do this."

It's important to the sisters that younger people learn their tribal traditions. They give basket classes and also present demonstration programs on Washoe culture in many places, from the Meneely School in Gardnerville to many museums all over traditional Washoe land. They recently taught eight elementary school girls from Dresslerville how to make cradlebaskets. They are subjects in a video which can be seen through the education department of the Washoe Tribal Offices, and they have both passed down their knowledge under the Nevada State Council on the Arts Folklife Apprenticeship Program. Apprentices were niece Cynthia Foster Rodriguez ("she took to it so naturally!") and Theresa's daughter, Sue Coleman. Theresa's son, Bill, works with willow too, making sweat lodges and furniture, and another niece, Norma Smokey, is also learning from her aunts; in return, Norma drives for them when they go gathering.

"How long does it take to make one basket?" they ask my question back at me, thinking about it. "Well . . . it takes four hours to gather, or

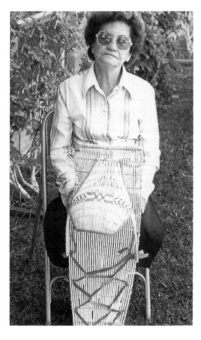

Fig. 54. *Theresa Jackson posing with a cradlebasket she has made.*

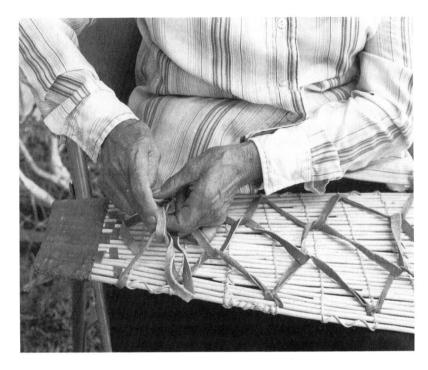

Fig. 55. *Theresa Jackson adjusting the buckskin ties on a cradlebasket she has made.*

you can waste a whole day," JoAnn laughs. Theresa adds, "If you find a good stand, you have to cut as much as you can!"

"Then," says Theresa, "there's the cleaning process; that's the most time-consuming." JoAnn says, "It takes 60 to 75 willows for the bottom of the cradlebasket. Then you have to get your threads ready and let them dry out about 10 days. It's hard on your hands and fingers! Then about another week to make the bottom. Then you have the top. It will take over 120 little tiny ones, depending on the design." She thinks a minute. "I'd say it takes at least two weeks total if that's all you do."

We felt a deep bonding with the Smokey sisters, who were so willing to share their culture with two white women, members of the People who once denied our restaurants, even our schools to them. Their philosophy can be summed up in the final sentence of the Governor's Breakfast prayer that Theresa gave: "It is our prayer that all races of people can learn from one another and live in peace, for we are all Your children."

In 1995 the sisters received the State of Nevada Governor's Arts Award for excellence in the folk arts, an award the Nevada State Council on the Arts bestows upon the state's finest folk artists.

Lilly Sanchez
Shoshone traditionalist

We talk to Lilly Sanchez on the Duckwater Reservation, which is situated in Railroad Valley between the White Pine Mountains on the east and the Monitor Range on the west. Her ancestral home is part of a huge tract of Shoshone land, land which the Newe still own, confirmed by a treaty signed with the U.S. government. She presently lives with her husband, Joe Sr., at Stillwater, near Fallon, but returned to her homeplace to act as organizer and storyteller during the annual Citizen Alert Caravan through central Nevada.[3]

Lilly is everywhere—teaching the intricacies of traditional Shoshone hand games, bustling around her wood stove in the huge, spotless family room/kitchen organizing the potluck dinner, stooping to answer a question from her two-year-old grandson, Oren, who just *has* to know the answer *now*, and later telling old Shoshone stories about flying wolves and water babies around the campfire while children, Native American and white, one by one fall asleep on piles of blankets.

It has been a long day for those of us traveling with the caravan. The last 34 miles on a dirt road out of Eureka seem as long as the first 200 miles along Highway 50 east out of Reno. It is narrow, rocky, and barren, and I wonder how people can make a living or even live a decent life in this land of little water, no trees, not even much sagebrush, and plenty of good old Nevada dust. But the scenery soon changes.

The road takes us past a hot springs lake, its steam rising in the cool morning air, and then dips into a picturesque valley of trees, ranches, alfalfa fields, and a scattering of homes. We have reached the oasis of our destination—a ranch where horses graze in a watery meadow and cottonwoods and silver-tipped leaf trees line a huge yard. I spot a bonfire set up in front, all ready to burst into red flames after dark, a homey white house nearby, and in back a traditional sweat lodge. The beautiful scene is certainly worth the trip.

Lilly's interest in making baskets started in childhood. Although only six years old when her grandmother, Mary Sambo, passed away, Lilly remembers carrying willows for her. Lilly also remembers her mother, Agnes Penola, making cone baskets, cradlebaskets, winnowing trays, and laundry baskets; Agnes also tanned hides and made moccasins and long

gloves. "When I was a little girl, she made a newborn basket," she says. A newborn basket is a temporary basket with no hood or covering, Lilly explains. This basket just lies flat and is kept for only five days. Then the big cradleboard is made.

The women in her family were afraid when gathering willows by themselves because white men sometimes came after them. Lilly told us that long ago, Shoshone women throughout the valley were raped and assaulted by white men. Once two Shoshone women in self-defense halted an attack by two white men. One day, in anticipation, they cut long willow branches; when the men appeared and began their attack, the women suddenly turned around and whipped them so hard they cried! The men never bothered them again, Lilly says with pride.

"Mom was not always home," Lilly answers my question about family life. "When Dad was around he was always working. My grandma and grandpa raised me during my early childhood. When I began school, I

Fig. 56. *Lilly Sanchez examining a willow branch she has cut.*

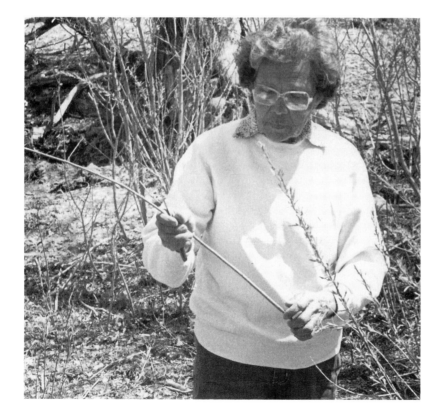

think about five or six years old, I spent more time with my mom." When she was a schoolgirl Lilly would come home and tell her mother what they had learned about Indian history, and her mom would say, "That's not the way it was." But they couldn't tell the teacher the true story back then, she says.

"I remember a couple of family members would be sent out on horseback to scout out good pinenut harvesting areas." They also made temporary baskets, which they would burn in the mountains at the end of each season because they were well worn and covered with pitch.

During pinenut picking, Lilly said, each family had a large burden basket. The children shared a smaller version of the burden basket (*ga koo du*) with adults and each other for pinenut gathering time.

("Now," Lilly interrupts her story, "we have so much trouble because the only thing kids think about is TV.")

The smaller baskets were set in a nearby bush while they were being filled. Once filled, the smaller baskets would be emptied into the big strong basket. Later, the pinenuts would be taken out and cooked.

Lilly says her grandfather would tell stories in the fall or winter, after dinner when it was dark, then make her repeat every word until she got it exactly right. Many of the Shoshone creation stories involve baskets, she says, adding that the stories tell in many verses about the totality of life.

Fig. 57. *Burden, or cone, basket by Lilly Sanchez.*

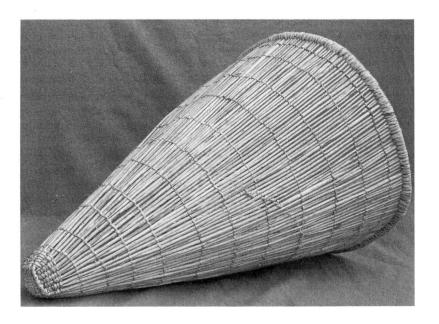

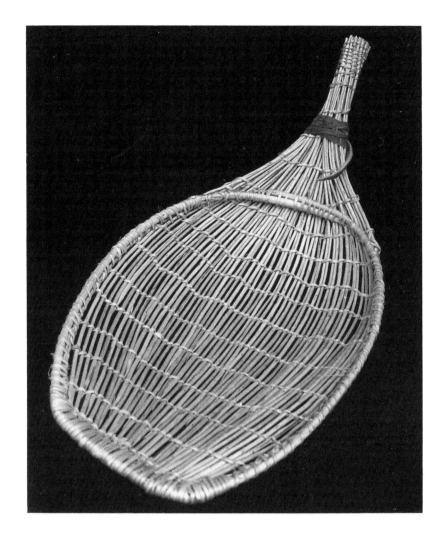

I ask if she will tell me one of the stories. "Oh, Grandpa said you don't tell stories in the middle of the day," she said. "Only after dark."

Lilly started making baskets when her children all grew up and moved away from home. "I started thinking about my grandma, my mom, and others, and wondered, 'Why can't I make baskets, too?' That's what got me started. I've showed younger Indian people how to work with willows; I like to see them learn how to do baskets. I share the things my grandma and my mother taught me. You know, when somebody shows you something like that, you have to pass it along to others. You don't just keep it to yourself. I want their great-grandchildren down the line to carry this on, so it just won't stop here with me."

Fig. 58. *Seed-beater basket by Lilly Sanchez. Seed beaters are used to hit the grasses and catch the seed as it falls.*

I remark on her knowledge and continued work with an incredibly complex and resourceful Shoshone tradition. She answers, "I carry it on so my children and great-grandchildren down the line will see there was something like this way before their time. Those disposable diapers they have now—there used to be buckbrush bark, woven buckbrush diapers."

The memories linger of Lilly Sanchez wrapped in a blanket against a cool and breezy night, her warm, strong face lit by the full moon and the crackling, smoky bonfire, telling us in the circle her stories of flying wolves and water babies and singing her beautiful Shoshone songs.

Irene Cline
Paiute basket weaver and beadworker

I first see Irene Cline at the September Numaga Indian Days celebration at the Reno-Sparks Indian Colony. As I walk along, listening to the drums getting warmed up before the dancing begins, gawking like the rubberneck I am at the incredible array of clothing around me, I try to

Fig. 59. *Irene Cline holding one of her beaded round baskets at the Reno-Sparks Indian Colony's Numaga Indian Days. (Photo copyright © 1995 by Chuck Fulkerson)*

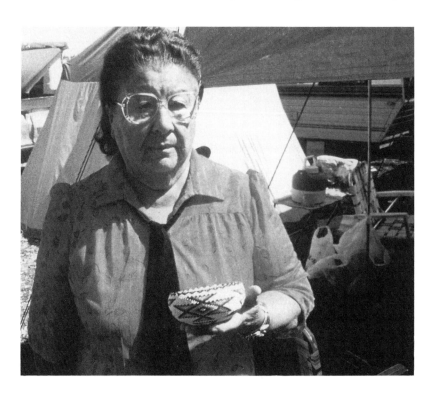

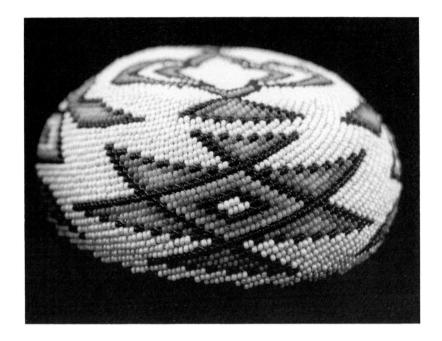

watch for the woman selling baskets I had heard about. But, given the warm day, the stands of Native-made art, the drums, the smell of fry-bread, and the bright and authentic outfits decorating beautiful people, it is hard not to be distracted. I want to stop at each stand, I want to touch the bells on the dancing outfits. I hunger for something I do not, nor will I ever, have: a strong, deep heritage with customs and traditions to sink myself into.

But I would never have missed Irene Cline. At the end of the last aisle, next to the frybread stand, she moves behind a cloth-covered table, and beside her booth flaps an American flag imprinted with the figure of an American Indian. She is wearing a beautiful bright red dress and is in the process of selling several beaded salt and pepper sets to a man who turns out to be Elwood Lowery, tribal chairman of the Pyramid Lake Paiute Tribe. Mr. Lowery buys her beaded work to sell at the Native-owned Marina at Pyramid Lake. Irene has several small round "trinket" baskets for sale, some beaded, others pure willow baskets. She has sold several already, and it doesn't take much to realize what a prolific basket artist and beader she must be. Her baskets measure three to four inches across and about two inches high. She says, in her soft and gentle voice, that

Fig. 60. Beaded round basket by Irene Cline with a traditional Paiute design.

she sells baskets at different powwows. And then: "Some peoples know about me and they'll go to the house."

Irene was born at Schurz, the Walker River Paiute Reservation and the largest entirely within Nevada borders, located about 40 miles south of Fallon on Highway 95. She has been making baskets for twenty-five years, and her near-perfect work bears testimony to time spent weaving. She moved to Oregon, where she lived for thirty-two years; when her husband retired, they returned to the reservation. I ask her how she learned to prepare willows and weave baskets.

"I used to have to buy baskets from an older lady there [at Schurz], named Nina Breckenridge. I'd sit and visit with her and watch how she's doin' it. I thought, if she can do it, why can't I do it?"

From her Oregon home, Irene would come back to Nevada and get the right willows and take them back to Oregon. She says she practiced and practiced making weaving strips, splitting the willow three ways, taking the skin and the core off. "You can feel it when you take the skin off," she says. Her near-perfect round shapes evolved because a white buyer of Indian-made goods insisted on it. The buyer would set the basket on a table, then stand over it and twirl it around. If it didn't go around in a perfectly round shape he didn't want to buy it. "I told him, if it's made by hand it's going to be a little off," she says. Her baskets can be found in museum collections and some of the shops listed in chapter 9.

Her beaded baskets are exquisite, the beads very, very small, the way the design follows the basket's contours, flawless. "I plan the design out in my head. I figure it all out, then you count the beads as you're going along. As you get lower, you reduce the beads. See?" She holds a beaded basket out for my inspection. I hold up another basket with an unusual diamond design and ask where the design comes from. "That is from when I was a little girl in Schurz," she says. "It's been kicked around Schurz, for a hundred years or longer."

A white woman and man have been hovering around, listening to our conversation quietly. When we pause, they buy the basket we've just talked about.

Irene remembers her grandmother once making great big clothes baskets and using roots for color. I ask her if they ever used wild rose in the old days. She said, "My tribe took a certain bush, then they dried it and

boiled it to get color; then they dipped the strips in there." When young, Irene watched her grandmother melt pitch and paint it on the water baskets. She repeats the lament of many of the weavers we talked to: "I wish I'd paid more attention." She adds thoughtfully, "There's a lot of history I don't know; I didn't question the old people about it." Then she says, "They try to teach the younger kids at Schurz, but they don't take interest in it."

Recently, Irene's eight-year-old granddaughter, Neeya Mullins, has taken up basketmaking, and Irene is very proud. When I ask how she taught Neeya, she smiles. "She just see me do that. Whatever I'm doing, she does it, too!"

Neeya's first complete willow basket hangs in Irene's house, quite an accomplishment for one so young.

Irene uses very small beads and figured out herself how to stitch them onto the basket in intricate designs. "Nobody showed me how!" Her baskets feature beautiful starred bases, and white is her favorite background. "White, red, and black are our good Indian colors."

Irene picks all her willows at Thanksgiving, then spends the winter making baskets. It takes her about a week to weave a three-inch basket and another week to stitch the beaded design on it.

One lone bead in a contrasting color at the very base of the basket is her signature.

Florine Conway

Washoe weaver

Florine Conway went to Schurz to live with her husband many years ago, even though she returns to Washoe country to visit and to gather the willow she knows best. We drive to her home in sweltering 100-degree summer temperatures; we welcome the cool, deep grass and the large shade tree, whose leaves rustle in a fresh breeze, in a front yard bursting with flowers. A vegetable garden grows in the back, a lawn sprinkler chugs along, and her little dogs, Missy and Gypsy, bark their welcome. We sit in the shade of the tree visiting, and from time to time Florine pauses to look at a nest of robins. "See my family up there?" she points. "They're trying out their wings." Florine's husband passed away the pre-

vious year, and she counts on the companionship of the robins and the dogs. She has recently begun making baskets again after a long interval spent caring for her husband, for, she says in her soft, gentle voice, "You have to be in the right kind of mood to make a basket."

And Florine's baskets are beautiful. "My mother used to tell me the Wyatt family [her father's family] were related to Dat-so-la-lee in some way. She used to say, 'Maybe you'll be the next Dat-so-la-lee!' " Florine's mother, Frieda Smokey, was the designated basket weaver in her family

Fig. 61. *Florine Conway sitting with a friend as she works on a round basket in her yard near Schurz, Nevada.*

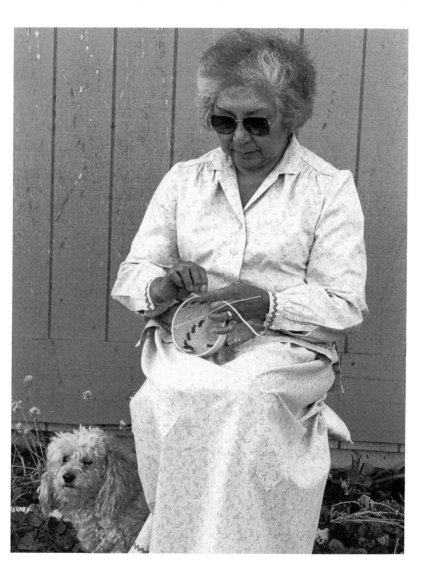

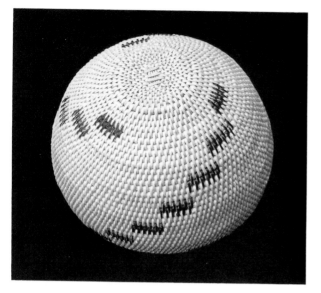
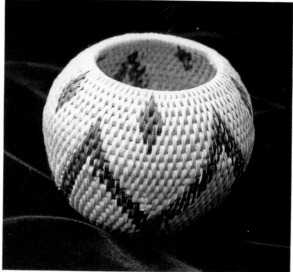

and passed the knowledge down to her daughter.

As far back as Florine can remember, people in her family were making baskets. "I always see that growing up." She has fond memories of her grandmother, Nancy Emm, and she stayed with her at Camp Richardson, Lake Tahoe, a favorite camp of the Washoe people. Nancy Emm made baskets and sold them to tourists who stopped by. "I made my first basket there. I don't know how ugly it was!" She laughs. "I was about ten when I sold my first basket; I was thrilled when the man handed me two dollars! I was *so* proud of it, I didn't know how badly I made it!"

Her other grandmother, Sadie Smokey (her mother's mother), was also a basket weaver and made a lot of different styles. And Sadie's mother, Mendy, did fine woven winnowing trays, "another thing I've been tempted to try."

There was a long span of time when she stopped making baskets. "I was thinking about boys!" she says, laughing.

"I always stayed with round baskets," says Florine. "I never tried any other kind." She uses redbud for color, building her own step-up Washoe designs, and experiments with beads sometimes; she works certain types of beads in to make them come out even. "I just put on what I like and not what I think people would like."

Fig. 62, left. *Round basket with a redbud design by Florine Conway. The bottom seen here is a diagonal interpretation of traditional Washoe patterns.*

Fig. 63, right. *Willow round basket with design in redbud by Florine Conway.*

She talks about going all over gathering willow and how hard it is to prepare the strands and shave the tall willows for weaving. "You have to prepare everything before you start," she says. "You have to shave it [the willow] down. Feel it with your fingers to know where the thick spots are. Wherever it's a little thicker than other spots, it'll break when you use it." She laughs again. "My grandma used to moan when she did that!"

"I learn as I go along," she says. "You learn by your mistakes. People can tell you how to make them, but they can't get your hands to do it. You have to learn by yourself, so that's how I did it. It's not as simple as it looks!"

"But the hardest part is starting." In the past, she made her basket starts with a negative space, or a hole, at the beginning, but the store buyer in Virginia City didn't want it. Now she uses a different start; she gets a wet, flexible thread, wraps it around three to four times, then starts her stitches. And when she puts designs in, she counts each stitch. Her signature is a turquoise bead at the bottom of each basket.

She talks about her children and her three granddaughters. "When I was their age I was too busy raising kids, and then working after they left," she says, adding, "I'd like to see at least one of my girls learn how to do the round basket. I think they'd take to it. My girls like natural things like gardens and flowers. They like working with their hands. I tell my girls, 'One of these days—?'"

Florine received a grant from the Nevada State Council on the Arts Folklife Apprenticeship Program for teaching her craft to apprentice Tammy Crawford. She receives very high prices for her baskets (we saw one purchased at the Gatekeeper's Museum Outdoor Show in Tahoe City, California, for $1,000). It is so like this warm and modest woman to say, "I still haven't got my baskets how I want them to be. I want to try new things."

Evelyn Pete
Shoshone traditionalist

Evelyn Pete, like her sister, Lilly Sanchez, is steeped in the tradition of the Shoshone people and of their own large family group, the Blackeye family. As we bump along the now familiar dirt road out of Eureka in the

Fig. 64. *Evelyn Pete holding a rabbit-skin blanket she has made.*

general direction of Evelyn's house at the Duckwater Indian Reservation, we're worried. We're late and know we have to conduct our interview and be out of Duckwater before the Nevada darkness closes in. Evelyn has not answered our letters; she has no telephone. We want to meet this woman who knows how to make a water basket—the only person left in Nevada, to our knowledge, who remembers how it is done and has agreed to make one so we can observe the process.

Now here we are, again bumping over the rocky road to Duckwater, unsure of exactly where the house is or whether we'll have anyone waiting there for us. We are one hour late. My foot goes down a little on the accelerator.

Fig. 65. *Evelyn Pete sitting by the creek in her backyard at Duckwater, Nevada, weaving a winnowing basket.*

We get a flat tire.

We are stranded in a desolate place, the sun ever traveling toward evening. The tire rim will not budge. Fortunately for us, photographer Kathleen is also a runner. She dashes toward the first house we see, way down the road.

Miracle! The neat little white house belongs to Evelyn Pete! She is waiting for us! Her son Mitch, who is visiting his mother, lays down a beautiful traditional pipe he is beading and comes with his girlfriend, Cheryl, to change our tire. Evelyn's brother, Nye, is there also, leaning over a traditional drum he is making.

Evelyn herself is sitting under a tree beside a gently bubbling stream that makes a little pond in one spot, and there her basket materials are soaking. She looks up from the winnowing basket she is weaving, and the sun makes a halo around her shiny black hair. Nearby on the grass sits the biggest burden basket I ever saw, and a rabbit-skin blanket hangs on a line stretched between two cottonwoods, swaying in the breeze. We feel spellbound, almost as if we are two other people in a movie we're watching, and for a while it is hard to remember what we are doing here or what we're supposed to say.

It is a scene neither of us will forget. The family speak to each other in their beautiful Shoshone language; and after the others leave to go spear fishing, Evelyn begins talking to us. She recently went pinenutting with her *wosa*, or cone basket (she tied red rags on the basket because it was hunting season), and now, with her *yantu*, or winnowing tray, she demonstrates the winnowing process for us in a fluid, experienced wave of motion. "Go up and down, then across; the little ones [rocks, etc.] come out the bottom." Her basket moves through the air with the knowledge of centuries.

We see two flat-oval, perfectly executed basket starts (her mom, Agnes Blackeye Penola, showed her how to do that, she says) with willow that is almost white. "I lived with my mom and she took care of Mitch when I got married."

Fig. 66. *Detail of Evelyn Pete's hands working on a winnowing basket.*

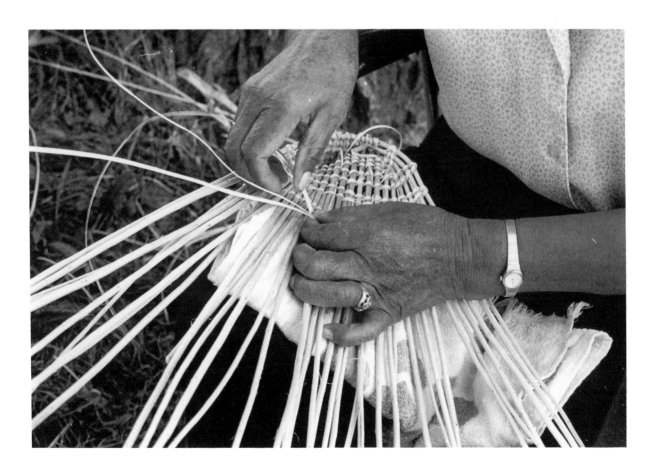

Evelyn says it isn't so hard to make a water basket. "You get pitch out of a piñon tree with sticks, then you boil it for long time, maybe a day or longer. Then pour it in the hole and shake it." Her son in Utah used to carry water in one, she says.

She also may be the last person to make the traditional rabbit-skin blanket. Her son Doyle Pete shoots rabbits for food for people at his home on the reservation in Goshute, then saves the hides for his mother. He also gets deer hide for her and she makes slippers, gloves, and many other things, tanning the hide in the old way. ("I told my mom I wanna learn. 'Go get an old hide and scrape it,' she said. 'You're gonna get a lotta holes.' I scraped it and I got a lotta holes in it!" She laughs.)

To get pinenut soup, she says, boil the nuts like beans, then grind them to get pinenut gravy.

One of her great pleasures is her six-year-old granddaughter, Desiree, who once lived nearby and wants to learn things from her grandmother. Especially willow work.

"I told her, hold this with your teeth and work these other two with your hands, and she said, 'Grandma! Grandma! I broke it off!' and I said, 'Try again.' So she did! I told her I'd teach her more, too." Evelyn adds, "She want to do it, I tell her the right way."

Evelyn has made many kinds of baskets, including cradlebaskets, and, along with Lilly and another friend, Sophie Allison, she demonstrates and sells them at the annual Clark County fair in Logandale, Utah. She is sad that young girls don't seem interested in making them, just buying them. But she was asked to demonstrate at the Clark County fair recently and is impressed that people were so interested.

Evelyn works with willow, tans hide the old way, makes slippers and gloves and rabbit-skin blankets, goes to the mountains to get the piñon cones, cooks them, winnows the nuts, makes pinenut soup, and teaches her granddaughter. This in addition to a job at the day care program on one reservation and as a cook on another.

"I have to do something!" she says.

We ask what advice she would give a person who wants to learn about willow baskets.

"Just *do* it!"

Theresa Temoke
Ruby Valley baby baskets

The trip to Theresa Temoke's home in northeastern Nevada is highlighted by a breathtaking drive through Ruby Valley, where she has lived all her life. We drive along the eastern side of the Ruby Marshes Scenic Area, past huge working cattle ranches, including the 7-H, where Theresa was a cook for thirty years, and turn the car up a willow-lined lane.

We conduct our interview from her front porch, with sandhill cranes in the adjoining field, hawks and eagles soaring overhead, and a broad, full view of the Ruby Marshes below. She and her husband, Frank, live on this 60 acres, allotment land that once belonged to Frank's father. Frank is now retired—he was previously a hand at the 7-H—and runs his own small cow-calf operation. Theresa makes cradlebaskets and has her family allotment on the nearby Indian Creek land. "A white guy almost took it [Indian Creek] away from me," she says. "I had to fight for it." They are proud that both sons and a grandson are Nevada buckaroos.

It is here that Frank's grandfather signed the 1863 Treaty of Ruby Valley. Frank calls himself the hereditary chief of the Shoshone Nation.

Fig. 67. *Theresa Temoke holding the beginning of the hood to a cradlebasket that she is making. (Photo copyright © 1995 by Kit Miller)*

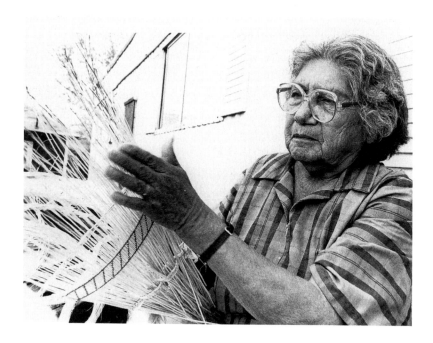

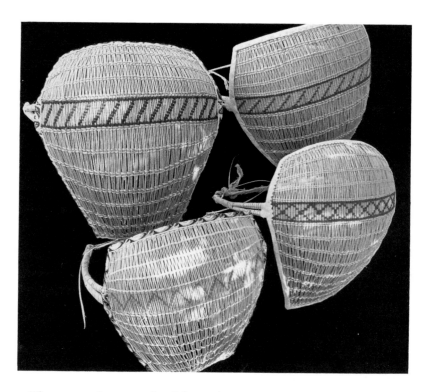

Fig. 68. *Four cradlebasket hoods by Theresa Temoke.*

Theresa was born nearby, "above the Cliff Gardner place just this side of the 7-H," in the year 1912; her parents worked there. She learned to make baskets from watching her grandma on her mother's side, Annie Mose. "I taught myself; that's the best way," she says.

Theresa has made baby baskets for a long time: "even when I worked. All my grandchildren got baskets like this"—she holds up one she is working on. "I even have 'em down in California, and sent two down to Carson last year." She was about 20 when she started to make them seriously and says she just had a knack for it. "My sister couldn't do it." She gathers her willow in October and November from a neighboring ranch, before the snow comes. Soaking time varies; Theresa has done it so long she can tell by the feel when a weaving thread is just right. Her frame is red willow, shaped and nailed into place, and she has her own tricks for obtaining the near-perfect hood shape so important to her. "Indians used to have that to protect their babies." She puts leather on the very bottom to make the basket stronger; and for this she tanned a hide last year and one this year.

I ask if she ever taught people how to weave, and she laughs. "I won't teach nobody. If they don't do it right, I get mad!" Theresa tried to teach her granddaughter, but "she'd do it a little bit and then quit." Her son, Frank Jr., however, does leather work, and her grandson, Richard Temoke, twists and braids horsehair into intricately designed ropes, riding crops, and hackamores.

Again she holds up her basket. "But this might be the last work I do. It's so hard on my hands." Somehow, we don't believe this. She is another winner in the Cradleboards with Babies contest at the Schurz Pinenut Festival. It will be difficult for Theresa Temoke to stop making her fine cradlebaskets, so much a part of who she is.

Fig. 69. *Interior detail of Theresa Temoke's cradlebasket.*

Sandy Eagle

Steeped in tradition

We have watched Sandy Eagle many times—dancing with the Paviotso group of Native American singers and dancers at various celebrations,

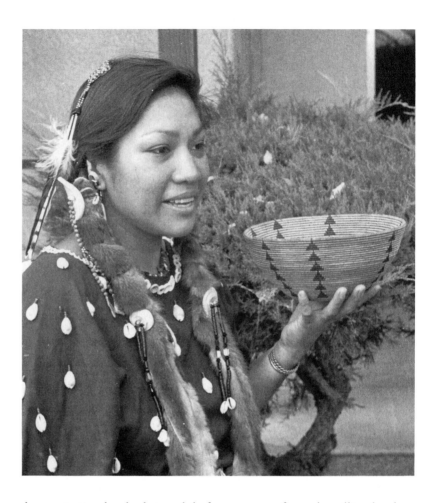

Fig. 70. *Detail of Sandra Eagle dressed for the Basket Dance with the Paviotso Dancers. Although she holds an old Washoe basket, it is traditional to dance with a Paiute or Maidu basket.*

demonstrating her basketwork before groups of people, selling her baskets at Indian art shows.

Sandy speaks reverently of her heritage and tries to live her life to be proud of it. "I've danced and kept my traditions alive, and my kids want to do that too."

Before we can ask about her wonderful miniature willow baskets adorned with unusual embellishments, she begins to speak of the grandmother who influenced so many descendants, Mrs. Adele Sampson, and also of her late mother, Jeanette Mitchell, who was always working on willows for making string or making baskets or cradleboard tops.

"They were the two women in my life that made me want to make baskets or beadwork items. I learned the willow work from my gramma,"

she tells us, "and my mom was always into making things. Becky [her sister] taught me how to make coiled baskets. The rest I started doing on my own—I self-taught myself." Sandy prepares her thread with a special knife ("a good, sharp one") used only for this purpose, rather than pulling it through a hole in a lid.

Sandy's work reflects a distinct, individual style; as she says, "I do it the way I think and the way I like. It works for me."

Norm DeLorme explains why Sandy's baskets are so distinctive. "She learned from Adele Sampson's telling how Adele's sister, Celia Arnot, did it. It's a family technique, passed down." He adds that Sandy's distinct style is a result of the way she sews a bead between each coil stitch. "Some old collections have Celia's work," he says, adding that Sandy took it a step beyond Celia's. "She puts feathers and shells in the rim. Her work is two steps beyond normal beaded basketry."

Sandy's miniatures are often quite small—smaller than her smallest fingertip. She must keep her nails trimmed, to "keep them out of my way." Her embellishments vary from basket to basket. One time it may be small white shells; another time it might be feathers. Sandy says she got these ideas from the Pomo people of California. "I love their baskets. I translate them into my own styles." (Feather basketry is an old Nevada

Fig. 71. *Sandra Eagle holding in her hand five miniature beaded baskets that show her distinctive style.*

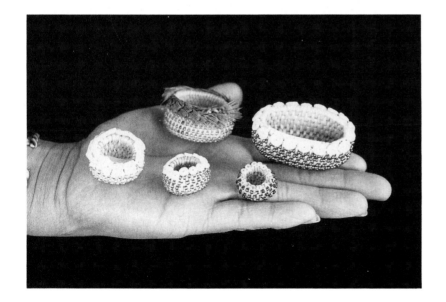

tradition and dates back 1,000 years.[4]) Another basket is rimmed with special blue feathers from the neck of a pheasant. Still another may carry a design in redbud of the scene Sandy sees every morning from her front door: the pyramid at Pyramid Lake. Another is adorned with a certain type of shiny seed bead, spaced so the willow shows through. The shapes vary too and may be oval or round. Her ideas just keep coming. She says, "Things come to me and I have to make them."

She also makes doll cradlebaskets, which are sold in several stores. She made round medallions and earrings with willow and redbud, which she sold when demonstrating at Wa She Shu E' Deh, an annual festival at Tallac Historic Site, South Lake Tahoe, California.

Sandy poses in her dancing dress so we can photograph her, holding her favorite Washoe basket. She has made her complete outfit and wears her great-grandmother's beaded dancing pouch. She loves dancing and was honored when her cousin, Norm DeLorme, chose her to be a part of the Paviotso group of singers and dancers. This group has revived some of the ancient Paiute dances, and they perform the Basket Dance each spring. "I want to help keep those old Paiute dances alive," she says, adding that Norm has played an important role in that effort. "If it wasn't for him, we wouldn't be doing them."

Sandy sells her baskets at powwows, demonstrations, and Indian markets, as well as to stores and to traders who take them to other parts of the country.

I ask her what advice she would give to someone who wants to learn to make baskets. She says, "They should learn by watching and find out if someone is willing to teach them how to work the willows. I myself don't teach it. I want to teach my own kids first. It's a family thing. It does take a lot of time to find and prepare the right willows for use to make any baskets."

Emma Bobb
Longtime Yomba Shoshone basket weaver

To get to Emma Bobb and the Yomba reservation, we drive east toward Austin on Highway 50, recently dubbed the "loneliest highway in the world." But we don't think so. The fresh smell of spring sagebrush floods

the Reese River Valley and forces its way into our car, filling it with fragrance. We whiz by great sculpted mountains, their peaks draped with snow, and gape at the incredible desert color, trying to commit the soft greens, coppers, ochers, and umbers to memory. Entranced, we nearly miss our turn at the tiny wooden sign that reads simply IONE. The pavement quickly turns to dirt, and gradually the next 40 miles stretching along a straight and dusty road begin to seem like 400. And then—suddenly—we see them everywhere on the desert floor—creeks flowing randomly across the valley (this in a drought year), and along this water grow great bunches of sprouting willow. For the first time we see the beautiful red willow for which Yomba is known, brightly contrasting against bursting green leaves.

We pass a field where two men rest their shovels to wave to us, then cross a narrow wood bridge and drive down a lane to the second house, as directed. Emma Bobb is waiting, smiling shyly as she leads us to her worktable just off the kitchen, where a basket is in progress. The walls are filled with mementos of family members—photos, newspaper clippings, awards. Here on the remote Yomba reservation, Emma Bobb surrounds herself with family members who live in other places. Talking about her basket tradition, she gestures with strong, sure hands, her silvery-black hair swinging as she turns. "When my mom was a girl they couldn't live without baskets. Everything was made from willow—plates, bowls, for drinking, everything!"

Emma's mother, Maggie Dyer, taught her to make baskets of many kinds—the water jugs, round trinket baskets, baby baskets, winnowing baskets, even laundry baskets. Emma would watch her mom split the willow, then try it herself. Maggie would watch Emma break the splits and say, "Try again!" She tried. "I finally got it!" Emma says the willows are bad now, with little rain or snow. "They used to be better in the old days."

I ask why she continues making them—is it to keep her culture alive? She laughs. "Oh, no! I make 'em to sell!" Emma also made her own winnowing basket (she calls it *wendu*), because she still prepares the pinenuts. She gathers the nuts in buckets and sacks in the fall when the rabbitbrush blooms. That is when the cones open and she can pull out the nuts and crack the shells. Then she puts hot coals in the winnowing basket and shakes and cooks them. She demonstrates her winnowing technique for

us, shaking the nuts in practiced up-down, right-left rhythmic motions. Emma asks if we will photograph just her hands, not her face.[5] We agree.

She was selected to work with Brenda Hooper under the Nevada State Council on the Arts Folk Arts Apprenticeship Program. She says Brenda finished a hood, but first she had to learn to strip the willow in the traditional way, which requires time and patience. She is also quite proud of the progress made by another student, niece Shirley Brady.

Emma is generous in her descriptions of technique, basket styles, and materials. "If you work every day it will take two weeks to make a [cradle-basket] top," she says. "One month for the whole thing." Emma's sturdy, old-style Shoshone cradlebaskets are still in demand. "Babies sleep better in 'em; they stay calm and they won't fall."

Emma points out a hood in progress. She first makes the design with yarn, weaving the base rods to the smaller hood willow rods. When weaving the hood, she changes pairs with each twining row. Then she turns and works from the inside as she goes back and forth. She will finish with four tight rows. This makes the hood very strong, she says. The back frame is made from a special kind of birch that is harder, she says. She has to go way down a certain canyon to get this.

Emma sets the hood down and returns to the table, where she is working on a round basket. Sitting on the table is a small plastic bowl of water containing a small sponge. She wets her fingertips on the sponge, then runs them gently up and down a willow string, as if she knows it well,

Fig. 72, left. *Emma Bobb showing how a new top she has made in the old Reese River style with a two-stick/three-stick foundation fits on an older basket.*

Fig. 73, right. *Emma Bobb working on a willow basket made with wild rose for the design. She coils in the old Reese River style with a two-stick/three-stick foundation.*

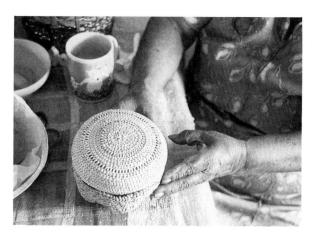

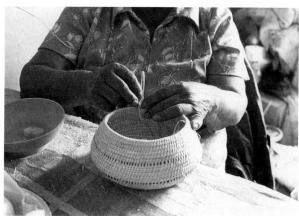

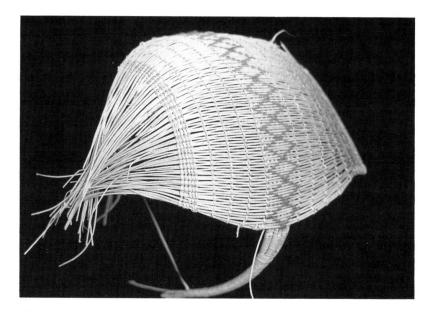

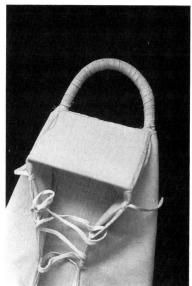

until the willow is damp enough to coil around the core of the round basket that is slowly growing taller as we speak.

Fig. 74, left. *Cradlebasket hood by Emma Bobb.*

Fig. 75, right. *Detail of a cradlebasket foot rest by Emma Bobb.*

Robert Baker Jr.
Cradlebasket expert

We meet Robert Baker, who is proud to be a full-blooded Paiute, at his selling table at the far end of the gymnasium at the Reno-Sparks Indian Colony. He is set up, along with many other Native American artists and craftspersons, at the only All-Native Christmas Art Market in Nevada. A thick, bright red cloth covers the table, and on it are Robert's perfect miniature cradlebaskets, as well as a miniature version of a traditional dwelling, made with grass and willow. The bleachers are pushed back into the wall, one slightly stuck out, and on it Robert's nephew sits, quietly listening to his uncle's answers to our questions.

My first question to Robert is the obvious—why would a man do this when all the other weavers are women? He lifts his head, his dark eyes glowing, and answers, "I do it because very few in my generation do it. When my grandpa died, I knew I had to." Robert holds up a chokecherry cradlebasket frame his grandfather made. "It's something that comes to

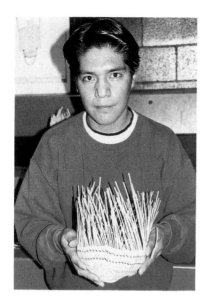

Fig. 76, top. *Robert Baker Jr. at the Reno-Sparks Indian Colony's Holiday Art Market, showing a traditional hat that he is making.*

Fig. 77, bottom. *Robert showing a tiny cradlebasket frame and hood.*

me and my grandpa on my dad's side. We're strong into that." Robert's grandfather, Paul Baker, was from Owens Valley and his grandmother, Lilly Baker, from Nixon.

"That's my biggest influence, being exposed to their work. And after they died, I said, 'I can do that.' I inherited a gift from them. It's automatically within me. I just start . . . and when I'm done, my creation comes out. Something inside of me is making me creative with my hands, and I'm very proud."

Robert knows his Paiute roots well. "I know what I'm talking about. The materials . . . the history. It comes from my area and relates back to my people at Pyramid Lake." The beaded buckskin borders are elaborate; he says that is traditional Paiute style—the traditional Paiute way is "adding one bead at a time."

He says his aunt carries the tradition on very strongly too—and with a nod sideways, "I hope my nephew will too. We'll have basketmakers within our family." Robert says his family is of big importance. Both the family and the Pyramid Lake Paiute people have their own designs, their own sizes and shapes, their own ways of working the willow, their own colors, often using white in the background of beadwork. "That's Paiute old style," he says. He shows us a willow hat he is making, like those his people once wore. Beadwork is another craft he excels at; he says, "I've always done it."

Our second interview takes place at the newly constructed Pyramid

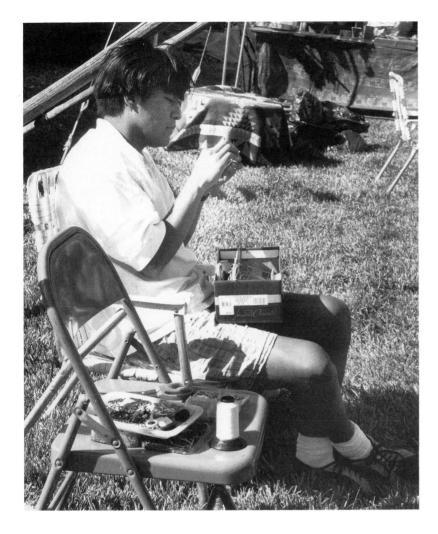

Fig. 78. *Robert working on a miniature basket at the Reno-Sparks Indian Colony Numaga Indian Days.*

Lake Marina. We are surprised to discover Robert is the manager here. He never once mentioned that fact previously, as if it were secondary to his cultural roots.[6] The artwork hanging on the wall behind his desk is his own—a pastel drawing of Pyramid Lake's other well-known rock formation, the Stone Mother; I turn to view the lake from his office window, squinting in a vain attempt to see this woman of legend on the other side of the lake.

This time he talks about the influences of Andrew Phoenix, his mother's father, from a longtime Pyramid Lake family, who knew how to tan hides and do other traditional work. "I have a lot of respect for what

he did. He just recently died. I can mourn, but now I know I move up. I'm the generation that can pass it [our traditional knowledge] on. Our kids will be able to remember."

His willow baskets are well crafted, and he agrees with our assessment because he knows how long he works at it. "People that judge your work will see that I'm using the right material."

Robert is deeply spiritual and takes what he does seriously. He always leaves an offering and makes a prayer when he gathers willow. He also gives a lot of his work away as offerings or as a gift that has meaning to it. When? "Whenever the mood strikes me. I get inspired." He said he recently made a gift to a friend who lives in northern California, where he visited on vacation. "He's always supported my efforts. I explained it was a gift showing my appreciation." Robert goes on, "When I give of myself in Indian way and Paiute way it has a lot more meaning than just the thing given. To me that's really important and also to the people who get it."

Rebecca Eagle Lambert
Paiute/Shoshone artist

We meet Rebecca at a personal willow-gathering site near her Wadsworth home. She likes to use the same patch every year, but it's not always good, she says, pointing out to us a thick rod that can be used for the inside of a basket. She demonstrates that for making the string you have to find thin willow, with no knots or branches coming out. "Just go inside the ditch here," she says, confidently leading us deeper into a willow thicket. Her feet are sure. She doesn't need to look down to avoid rocks and holes in the trail that is no trail. Rebecca knows where she is.

Rebecca is known for her miniatures—tiny willow baskets are stitched with bright colored beads in designs she dreams up in her head. Sometimes the little baskets become earrings and necklaces. She makes her living as a basketmaker.

As she cuts her willow, she begins to speak of the one who first taught her—her late grandmother, Adele Sampson, who, Rebecca says, remained active until the day she died. Mrs. Sampson would guide the girls—Rebecca and her sister Sandy—and Norm (their cousin Norm DeLorme) in the process and technique of splitting the willow for string.

Because Adele's health prevented her from going outside, Norm often would bring bunches of willow to her. "Gramma always told me to explore," Rebecca remembers. "Gramma wasn't so picky, but we learned everything from her. She knew which ones would be for string or for sticks [warp]." When Rebecca finally learned to split the willow, she says, "Gramma was thrilled to death!" Rebecca learned this at age twelve and she says it took her years to get really good. She was always doing some type of artwork, though, as was her late mother, Jeanette Mitchell, who had a lasting influence on her daughter.

"My mom was active until she died, even though she was hurting," she says proudly. Rebecca gave her first basket to her father, Harvey Eagle.

Fig. 79. *Rebecca Eagle Lambert removing the core of the willow with her teeth.*

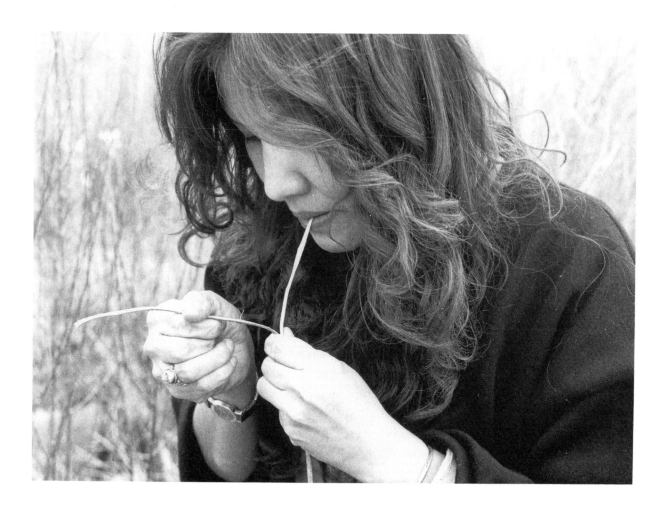

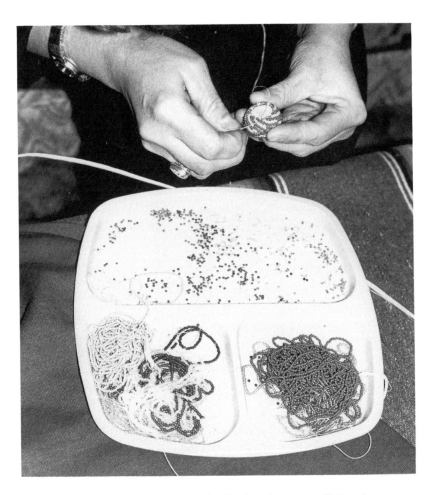

Fig. 80. *Rebecca beading a tiny basket.*

Rebecca says she makes her beaded baskets because of Norm's instruction and encouragement, and now "I can't give it up. I just keep doing it." The design work on her baskets involves counting beads; although she is known for the swirl, she says she has no idea what she's going to design when she begins. First she picks three to four colors, then she starts. "The design just comes to me," she says. Having mastered the familiar peyote-stitch technique, she began to create her own unique beaded patterns, favoring contemporary designs over traditional ones.

When asked how she does it, she answers, "It's simple. It revolves around counting your beads. When you come in, you deduct beads and when you go out, you add them. Everything has its place." I scratch my head. Simple?

Rebecca works at her craft on a small table especially set up in her home, right in the middle of all the family activity. The table is stacked with countless clear plastic boxes of tiny beads separated by color. A small willow basket is in progress, a needle and thread waiting. Many favorite mementos surround her work space—a baby basket on the wall, photos, Native-made objects, a blanket.

Rebecca taught her sisters, Tammy and Sandy, to make baskets, and she is teaching her two daughters, Yvonne, age seven, and Miranda, nine, how to work with the willow. Miranda can split willow too. Rebecca has demonstrated her craft at the Nachez school in Wadsworth and at many public places in the Reno/Sparks area. She was proud to be included in the Nevada delegation at the National Folklife Festival in Washington, D.C. Her work can be seen in the Reno-Sparks Indian Colony Christmas Art Market and in many area shops. Her baskets are winning awards, and it seems her career is just beginning to flower.

I ask her what advice she would have for someone who wants to learn about willow baskets.

"My advice to people is get yourself to explore it, because a lot of the older people are gone, and we have to do it ourselves."

Fig. 81. *Beaded basket and basket starts by Rebecca.*

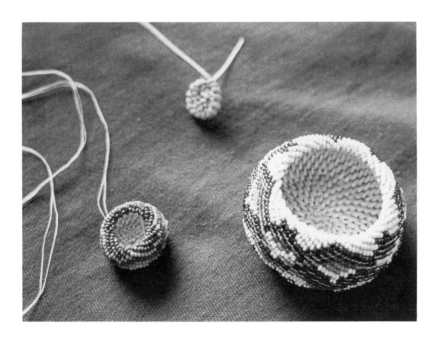

Bernie DeLorme
Supporter of Indian culture

Bernie DeLorme, a Western Shoshone Indian now living in Reno, has made a name for herself by presenting to the people of Nevada and across the country the many contributions, traditions, and beliefs of Nevada's Indian people. She is an accomplished weaver and beadworker from a long line of Western Shoshone basketmakers. Bernie, who began weaving twenty years ago, respects the weavers of traditional basketry as the keepers of Native American art, beauty, and vision.

She is well aware that the flow of most of the cultural knowledge was disrupted by the European invasion, government policy, and forced assimilation of Native Americans into the American mainstream and lifestyle. That awareness made her determined to join other Native American families to retain and perpetuate cultural and traditional knowledge.

Bernie was born Bernadine A. Sam on the Duckwater Shoshone Reser-

Fig. 82. *Bernie DeLorme leading the Basket Dance performed by the Paviotso Dancers at Degikup Day, Tahoe City, California. (Photo copyright © 1995 by Richard Quinn,* Tahoe World)

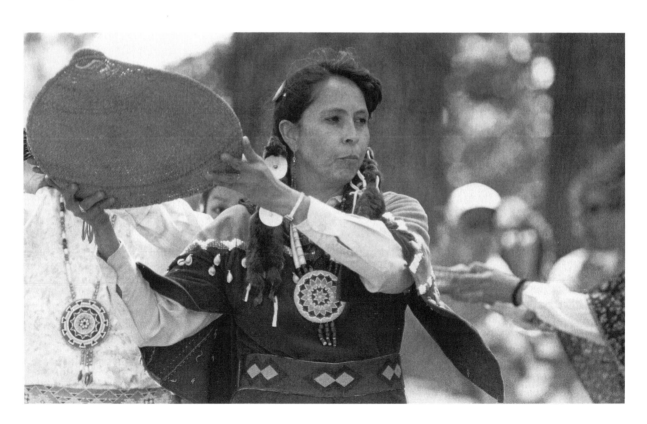

Fig. 83. *Three-rod basket by Bernie.*

vation in eastern Nevada. Her mother, Lilly Sanchez, is featured in this chapter. Her maternal grandmother, the late Agnes Penola, was acknowledged as a traditional basketmaker, craftsperson, and keeper of Western Shoshone traditions and beliefs. Another close family member is Sophie Allison, also featured in this chapter.

Basket weaving is a family activity. Years ago, Bernie and her husband, Norm DeLorme, transported his maternal grandparents to identify and process native plants and materials. Norm's maternal grandfather was the late Harry Sampson, noted Northern Paiute cultural informant and interpreter for ethnographer Willard Parks. His maternal grandmother was the late Adele Muzena Sampson, Washoe/Paiute basketmaker and craftsperson. Adele Sampson taught her family members all about her cultural knowledge. Her students included Bernie and Norm and their cousins Becky and Sandy Eagle. Following this ancient family tradition, Bernie has begun to teach her two daughters, Fay and Celia, about the cultural knowledge that she values. Other Indian people seek her assistance and advice as well.

Bernie specializes in coiled baskets, in the one-stick interlocking style. The basket that she makes is called the round basket and varies in size: large, medium, small, and miniature. After she has made the complete round basket, she likes to cover it with glass seed beads, with the style

known as the peyote stitch. Only the first row of beads is sewn directly to the rim of the round basket. The beadwork completely covers the basket with a beaded mesh, right to the base. Bernie never adds the round leather patch to the bottom of any of her beaded baskets, as other weavers sometimes do. And she is offended to see any of her baskets displayed upside down; she believes that when this happens, all the "good luck" is poured out.

Her colors and designs are envisioned and chosen based on her own traditions and beliefs. Her knowledge of traditional colors, color combinations, patterns, and favorite designs defines her completed beaded round basket. She has also made round willow baskets with designs made with devil's claw and California redbud.

When she's not making baskets, Bernie might be making a beaded bottle, crocheting, sewing, or going out into the community. She has worked with the Washoe County School District to make presentations and demonstrate her cultural knowledge and has volunteered her time to teach local Indian youths about Indian dances, games, events, and other traditional activities. She dances with the local Paviotso dance group and, with Norm, has sponsored an annual Indian Art Market and Christmas Sale for many years. The goals of the sale are to preserve Indian cultural arts and crafts and to promote local and neighboring Indian artists and craftspersons. The Art Market grows larger each year and is one of the Reno area's most popular events.

Bernie has traveled a great deal to promote her culture. In 1985, with the help of Nevada's Senator Paul Laxalt, she and other Indian dancers traveled to Biarritz, France, to dance and perform. Bernie and Norm were featured traditional artists, displaying beaded baskets and bottles, at the Museum of the Plains Indian in Browning, Montana. Along with other Nevada basketmakers, Bernie and Norm represented Great Basin Indians at the National Folklife Festival in Washington, D.C. Demonstrating weaving and beadwork, they also represented the Great Basin Indians at the presidential inauguration, "America's Reunion on the Mall."

Bernie is the only contemporary Native American from Nevada to have a beaded basket on exhibition at the National History Museum of the Smithsonian Institution in Washington, D.C. Her basket there is a fully beaded round basket with a turquoise-blue background, with serrated diamonds enclosing her traditional butterfly pattern.

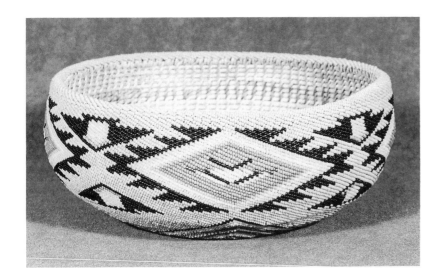

Several large beaded round baskets created by Bernie and Norm were acquired by the U.S. Department of the Interior, Indian Arts and Crafts Board, for exhibition purposes. Other beaded baskets are featured in the Yosemite Cultural Museum, operated by the National Park Service, at the Yosemite National Park, California. Beaded baskets and beaded bottles are quickly acquired by collectors and clients.

In spite of all the recognition, however, Bernie's home life takes top priority. Most of her time is devoted to employment and caring for her family and home. She considers family to be the most important value of the Indian people. And it is through the family that she extends her cultural knowledge. She enjoys returning occasionally to the Duckwater Shoshone Reservation to reunite with family members and to encourage the flow of cultural knowledge to all the young adults and children in her family.

Never one to rest with what she knows, Bernie is exploring new territory: she is now weaving using the traditional three-stick foundation coiling technique.

"There are other things I've wanted to do, like twine-weaving, fancy rim finishes, diagonal twining with designs and reversible designs," she says.

Bernie DeLorme joins traditionalists from around the state who are still making their baskets in the old way, still gathering the willow, still

Fig. 84. *Basket by Bernie DeLorme on exhibit at the Smithsonian Institution. (Courtesy U.S. Dept. of Interior, Indian Arts and Crafts Board, Museum of the Plains Indian and Craft Center)*

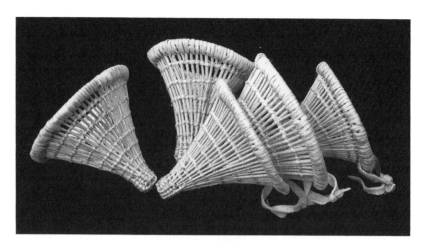

Fig. 85. *Miniature cone baskets by Sophie Allison. Note the double-woven square base.*

hoping a young person will want to learn, still strong in traditions and beliefs. Nevadans can indeed be proud of this woman's achievements.

Sophie Allison
Prolific weaver

We're lost and, as usual, late for our appointment. The road is dusty and alive with teenagers pulling horse trailers to Eureka for the annual high school rodeo days. Now we are once more at the beautiful Duckwater Indian Reservation, on a street with no name, hoping Sophie Allison will somehow magically appear and identify herself. We stop at a turquoise house where a pleasant-looking gray-haired woman sits outside on a wooden bench watching our progress. Can she tell us, we ask, where Sophie Allison lives?

The woman smiles. "I'm Sophie!"

Inside Sophie's spotless home we sit down to talk, and I immediately notice a close-twined winnowing tray hanging on her wall—it is only the second we've seen anywhere (the first was one that JoAnn Martinez made for the Nevada State Council on the Arts). What are these used for? I ask her.

"*Sa'a de'lwa*. For the little sunflower," she explains. "The bad one [extraneous material and dust] flew away." The winnowing-parching tray is used to process sunflower seeds. We are impressed not only with the basket's fine threads and perfect twining. Sophie has managed to make

subtle design stripes across the basket with light-colored willow threads.

She rises from her chair, goes to a back room, and returns with three cradlebaskets. She goes back for extra shades. Again she goes back. After several trips, the living room is bursting with baskets—a huge cone basket (*gow'was*), miniature cone baskets, and large and small winnowing trays (*yantu* and *teh'wa*) and cradlebaskets with colorful beaded shades in several sizes. We're overwhelmed. Never before have we seen this quantity, all of it perfectly crafted, and these unusual styles. In addition to the parching-winnowing tray, Sophie has been making the boat-type cradlebaskets for several years. She first saw one that Evelyn Pete had learned to make when she was living in Ibepah on the Goshute reservation. Sophie decided to try it herself. The resulting basket could be a piece of sculpture in any museum.

We have come to Duckwater at the right time. May 31 precedes the annual Duckwater Days Festival, and Sophie has made all her baskets to

Fig. 86. *Sophie sitting in her special weaving place outside her home and holding the baskets she has made for sale at the Duckwater Days festival.*

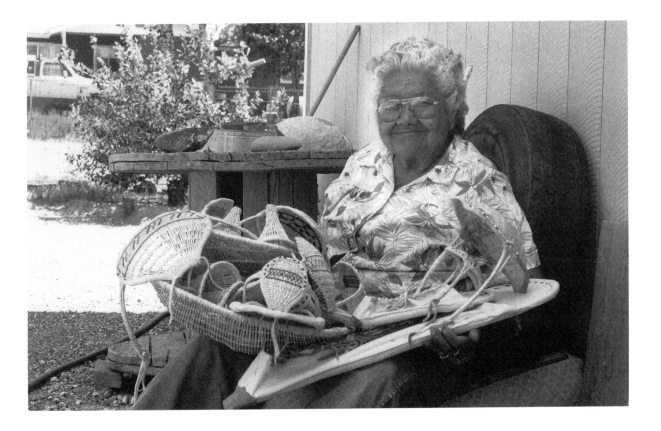

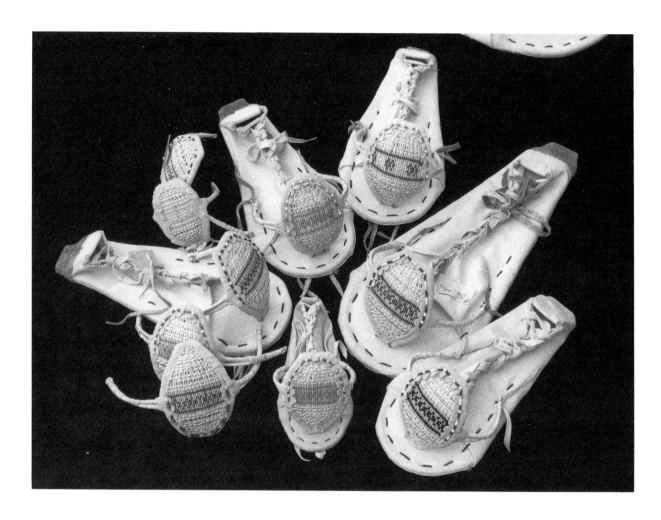

Fig. 87. *Assorted sizes of doll cradlebaskets with hood patterns of brightly colored yarn by Sophie Allison.*

sell during the festival, where folks will come from Ely, Elko, and other surrounding areas to buy.

We go outside to photograph her baskets in the natural light, and Sophie sits down on her bench, her back resting comfortably against a well-placed tire. This is where she works on baskets, her water pan on the nearby table, a recycled cable spool.

She gazes at the far-off mountains and talks about her grandma, Mary Blackeye, making baskets ("she made them real tight"). Sophie's mother, Minnie Blackeye Allison, made a few baskets for pinenuts, she says, but not too many.

"I seen my grandma make it." Sophie says you have to learn by watch-

ing, so she watched. "I don't know what they're doing." She laughs. She remembers she "had a feel" for willow when she was little. But Sophie learned the specifics fairly recently—"twenty or thirty years ago"—from a Shoshone lady named Lilly George who came out to teach them.

The willows are just a stone's throw away from her house, along a meandering stream. But there's only a certain place—from the bridge down—where they're good and strong, she says. She bends each willow before she cuts it; if it breaks, "it's no good." Sophie prefers getting her willow in spring, when the skin comes off easily and "you don't have to scrape too hard." In the fall, she says, it's pretty hard getting the skin off.

I've heard about a group of women and girls who want to take lessons from her, and I ask her about this. She shakes her head. "It's hard to learn. You got to show 'em how to split willow, make strings, find the strong one. It's hard to learn. I bet they won't all take it. It's hard." She laughs. "Some won't even go pick willow! And you have to know the whole thing! And it gets sore your hand—the way you hold your willow and knife . . ."

She pauses and waves at a neighbor, who returns the greeting, then settles back against the tire, looking once more at the mountains. "Too windy for baskets today," she says.

NONTRADITIONAL BASKETMAKERS

Three Native women make nontraditional baskets differing in materials, techniques, styles, or all three. Each takes her basketmaking seriously, and each has her own story to tell.

Larena Burns
Pine needle baskets

We have seen Larena Burns's pine needle baskets for sale at powwows, stores, and Indian markets long before we meet her. A lot of traders purchase her small pine needle baskets, maybe because they are different, maybe because she doesn't charge very much even though her work is meticulously executed.

We meet Larena and her husband, Frank, a Western Mono Indian from

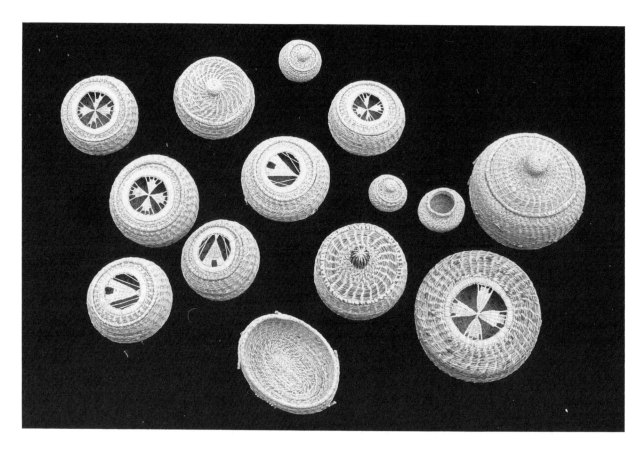

Fig. 88. *Selection of Larena Burns's pine needle baskets ranging in size from 1 inch to 5 inches.*

North Fork who is very much interested in baskets, at their home on the outskirts of Carson City, not far from the Stewart Indian Museum. It is a warm day in late summer, but their home, set on a little hill, catches a cool breeze. Their grassy yard is flanked with flowers and plants, a few trees, and, at the edge, a pile of piñon cones, their scales open, nuts long gone.

Larena, who is half Paiute and part Washoe, is an honest, no-nonsense kind of woman, the kind about whom fiction is written, for her heart is very big. She presents each of us with a small gift basket before we leave that day.

She remembers watching her grandmothers working. Annie on the Washoe side made baskets, and Mattie Voorhees on the Paiute side did lovely beadwork. "I didn't pay any attention to what they were doing," she laments.

Determined to learn, she went up to the Gatekeeper's Museum at

Tahoe City, California, where the late Marion Steinbach, a white woman who collected Indian baskets, taught pine needle basket workshops. There, she learned how to make baskets. "I wanted to know how to start," Larena says.

Start she did, and she's never stopped. "I've forgotten how she taught us to make pine needle baskets, but I tried to do it my way," using the old Paiute and Washoe techniques she remembered, even though she says, "Marion wanted me to do it the way she taught. But I don't. I use one strand and make Washoe stitches." Washoe weaver Winona James taught her the oval stitch, and she also does a split stitch. Larena uses pine needles as her core material and raffia as her thread. The long needles she uses are bull pine,[7] which Frank gathers for her in North Fork, California. She no longer uses bright colors in her stitching. Her raffia colors echo

Fig. 89. *Larena Burns working on a pine needle basket, using traditional Washoe stitches.*

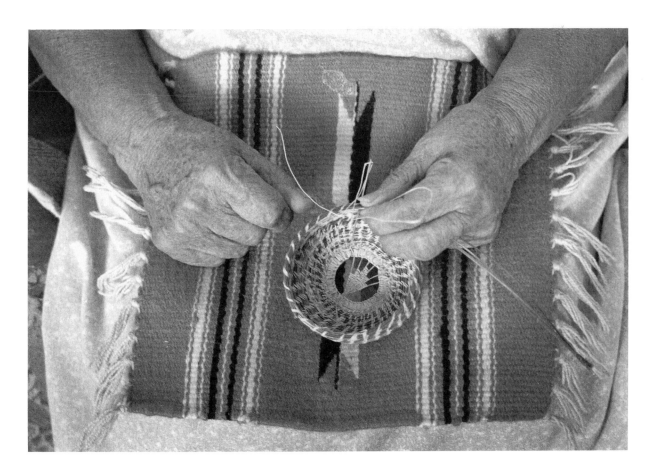

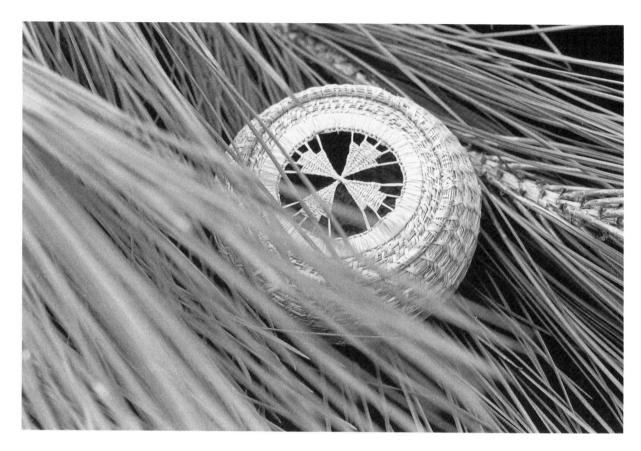

Fig. 90. *Round pine needle basket with decorative lid is nestled in a bull pine bough. Burns uses bull pine needles in her work.*

colors used in traditional baskets—black raffia for black fern and brown raffia for redbud. "Indians didn't use other colors, I guess," she says.

The dry needles are naturally turned to get the brownish color and are worked among the green needles. After stitching a round of the bundled needles, she often stitches back around the other way to make her baskets stronger. Her miniatures take many different shapes; one style followed the gambling cup of Mono tradition. Her pictorial stitched beginnings are often woven Indian images—the arrow and the leaf are favorites. Her daughter, Janet Fleming, designed a teepee image and, Larena says, "I copied that and it really sells. They sure buy teepees."

Frank interjects here, "She practically gives 'em away." Larena says, "I do it to make extra money."

Larena taught her technique to her daughter and another friend, J. R. Day; both are active pine needle basketmakers now. Both mother and

daughter demonstrated their craft at a large gathering at the Gatekeeper's Museum, a fund-raiser to house baskets from the Marion Steinbach Indian basket collection. Marion's husband, Henry Steinbach, donated a portion of his wife's collection of more than 800 baskets to the museum.

Frank is a supporter of basketmakers and acquires family baskets himself. He often returns to California to find traditional Indian-made work and purchases redbud and black (bracken) fern for many of the Nevada basketmakers to use. He is retired from a lifetime of working with his hands in carpentry and home building, an occupation learned when he was a student at Stewart Indian School. He has only good words for his training at Stewart, and he remains on the board of directors at the Stewart Museum.

Asked what her advice would be to young people who want to learn, Larena does not hesitate. "Go for it! I just learned what I wanted to and decided to do it my way."

Loretta Graham

Connecting two worlds

Loretta, a member of the Northern Paiute Tribe now living in Las Vegas, has been difficult to catch up with. We finally connect in one of our favorite meeting places, the Sparks parking lot of John Ascuaga's Nugget Casino and Hotel. Loretta has a lot to accomplish in this life. She is in the northern part of the state on a grant from the Nevada Humanities Committee, seeking work for an exhibit she is organizing, Nevada's first all–Native American arts and crafts exhibition.

"It's time to show everybody the richness of our culture here. We have a lot to be proud of."

Her children are with her. "Family means everything," she says, adding that when she works on her baskets and other crafts the kids are always right there. Loretta has always had the support and encouragement of her husband in her efforts.

Loretta was born at the Indian Hospital on the Walker River Indian Reservation at Schurz and raised on the reservation in Lovelock. Her family didn't do craft work, so she didn't learn traditional techniques, although all of her influences come from the beadwork, basketry, and

Fig. 91. *Loretta Graham lives in Las Vegas and weaves nontraditional basketry inspired by the traditional work of her people, the Northern Paiute.*

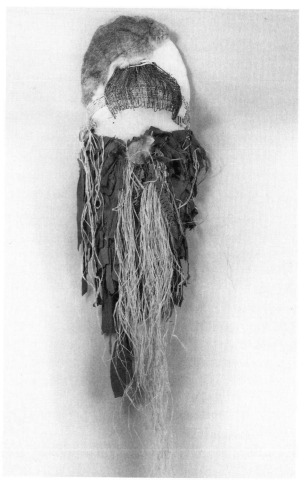

Fig. 92, left. *"Child's Cradlebasket" by Loretta Graham is a contemporary basket inspired by traditional designs. (Photo copyright © 1995 by Susan Mantle)*

Fig. 93, right. *"Desert Child" by Loretta Graham is a contemporary basket inspired by traditional designs. (Photo copyright © 1995 by Susan Mantle)*

leather work of other members of the tribe. She became interested after her son was born and she quit working to stay home. "I needed to keep busy, so I went out and learned and did as much as I could."

Her contemporary mixed-media work based on traditional designs has appeared in many galleries as well as in traveling and invitational exhibitions. She also participates in demonstrations and talks that introduce the traditional arts to Native American children in the schools. She has been a volunteer for the Las Vegas Indian Colony and is presently on the Parenting Committee for Las Vegas Indian Education. A volunteer with the Native American Student Association, she established the first Native American Humanitarian Awards Banquet at the University of Nevada at Las Vegas.

In 1992 she was selected to be in the book *Distinguished Women in Southern Nevada*.

In her letter seeking Native American artists for the all-Native exhibition, she said, "Looking into the past, and displaying our continual art forms, we can see the unlimited potential of the dreams which can be new stepping stones into our future."

Dreams are important to Loretta Graham.

Betty Rogers
Horsehair baskets

Betty Rogers lives in the Yerington area and has been making horsehair baskets for many years. Horsehair is the only material in her baskets. Even the stitching thread is horsetail, and she uses the somewhat stiff, natural flow of this material to create baskets in all of the colors that horses come in. She and her daughters, Elaine Smokey and Rosemary DeSoto, make baskets of many different sizes and styles; Rosemary even produces other forms, such as animal shapes.

Their baskets are collected widely, and a list of outlet stores can be found in chapter 9.

Fig. 94, left. *The colors of these horsehair baskets by Betty Rogers are natural. (Collection of Bob Smith)*

Fig. 95, right. *Beaded horsehair basket by Betty Rogers and Rosemary DeSoto. (Collection of Melvin Snoddy)*

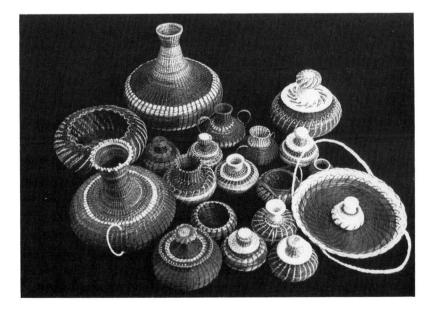

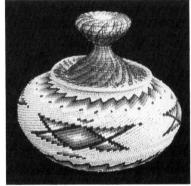

6

AN
AFTERNOON
WITH
TWO
APPRENTICES

TIME Late spring

SCENE 1 The living room at THERESA JACKSON's home in Dresslerville

A willow bundle is on the floor near THERESA *and some cradlebaskets—one old, one miniature, one in progress—are grouped on the coffee table. Sliding-glass doors at one end of the room, opposite the front entry, lead to a backyard where flowers and herbs edge a rim that overlooks a greening valley. There is a stone mano and metate in the yard.* THERESA, *who is* SUE COLEMAN's *mother and* NORMA SMOKEY's *aunt, holds some willow on her lap; when she isn't talking, she raises one to her mouth and effortlessly splits it into three pieces. Then she lays them down and starts another one.* SUE, *with a little experience, is showing* NORMA, *who is new to the field, a cradlebasket hood, explaining its construction.*

SUE: You start with the design first and then cut off the willow as you get down . . . The hood is one of the most difficult things you can do. If you break something you have to start all over again. Little ones have a hundred willows and big ones can have three hundred fifty!

(*They lean over the hood.*)

SUE: Be careful when you bend it over into the curve. Do it gently or it might break.

NORMA: I only do what I can do; then I leave it till I find out what to do next. I told my daughter, "Don't you plan on having any babies till you learn to make your own baby basket!" She says, "No, Mom, I got other things to do!"

(*Laughter*)

NORMA: Now I have a real hunger for it.

THERESA: It takes time. There was a time when people did it, but now you have other things to do. You don't want to sit and learn and don't realize how important it is.

I didn't always watch back then, and there Frieda [her sister] would sit and make little cone baskets to pick pinenuts. And Frieda used to take us up [to the pinenut mountain range] and put us to work. She would camp out there with . . .

NORMA: Me! I want to make more winnow baskets before I start on a hood.

THERESA: Good. You go out and sit with her [JoAnn Martinez, Theresa's sister] and work with her.

SUE: It should stay a family tradition. All Mom's grandchildren are crazy about their grandma. My dad died when I was nine and she raised us. You know, you appreciate more what your family has done as you get older.

NORMA: I want to make a winnow basket with a tight weave . . .

THERESA: You can do it! All it takes is lots of thread and willows.

SUE: And time.

THERESA (*examining the basket in need of repair*): That baby was in that basket till its feet were hanging out. To repair it I'll have to cut that broken willow and send it through. (*Laughs.*) They grab the sides sometimes and break it. When they get used to the basket they won't sleep anywhere else.

SUE: I've had lots of babies at my house and put them in there and they quiet down. They are so happy, so safe and secure.

Fig. 96. *Theresa Jackson, her niece, Norma Smokey, and Theresa's daughter, Sue Coleman, displaying some of their basketry.*

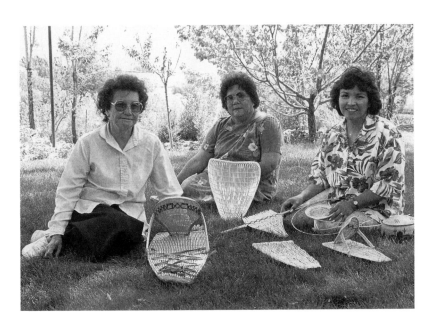

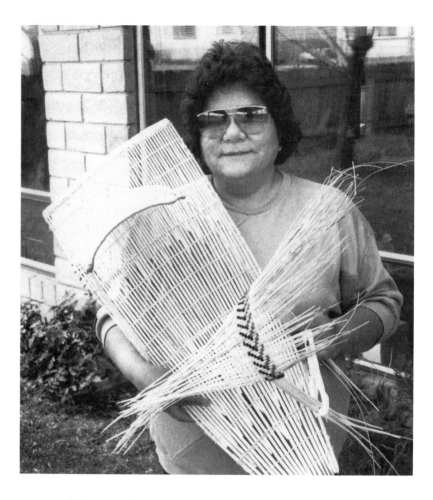

Fig. 97. *Norma Smokey holding a cradlebasket and an unfinished hood on which she is working.*

NORMA: They say if you tie them down they use all their other senses. I remember my little brother, we'd wrap him up and he'd walk around wearing his basket!

(*Laughter. Then* SUE *pulls her baskets together—a hood beginning, her first baby basket, and her first round basket.* NORMA *studies it, then asks* THERESA *a technical question, pulling out a basket in progress.*)

SUE: Don't put hers beside mine!

NORMA: Do you have to bend the willows on the baby basket?

THERESA: Not really. You could . . . [*Technical description follows*]

(*We look at pictures of redbud and bracken fern.*)

THERESA: It [redbud] grows like bushes. We buy or trade our willow thread to people in California for it; they don't get the good willow. The bracken fern is on Luther Pass. They gave us [THERESA *and* JOANN] per-

mission to get it, but it's hard digging. You have to have a man to help you. It grows sideways. You use the root. Peel the bark off.

NORMA: The other day I was real upset and my willow just kept breaking. I know I wasn't in the right frame of mind.

THERESA: She's got lots to learn yet as she goes along (*picks up Norma's winnow tray*). The sides are long. You curve it in and hold it when you put on the outside rod.

I started from scratch; I learned what kind of willow to get and how to split it to make the thread. Splitting into three ways is the hardest, and test while you're out there [gathering] to make sure they're good. I went out many times before I started making a basket.

When I was growing up here, my gramma was making acorn soup. She had a big pounding rock and we'd sit out there and pound these acorns into powder.

Now I'm learning how to make the round basket—by just sitting there and watching Florine [Conway]. She learned from her mom, Frieda. Frieda made her first round basket when she was sixteen. It had a lid and she gave it away. Now a niece has it. (*Looks at another picture.*) Elsie George—she and her sisters did beautiful work—made a round lidded basket and gave it to Susie for her sixth birthday, filled with gum and candy.

SUE: Not many young people are taking it up.

THERESA: Young people are gonna have to learn so they can teach their children. She'll [Susie] probably teach her children. I made a basket for my son Billie to keep this year.

SUE: It took me forty years to get a basket from my mom! My husband surprised me for my forty-first birthday! I started two years ago with Mom. This cradlebasket was my very first one. I gave it to my son.

(*Fade to view of the Carson River behind Theresa's home.*)

TIME Early spring, the following year
SCENE 2 Backyard, Dresslerville Senior Center
NORMA is proudly showing six winnowing trays she has completed.
JOANN: She really took to it!
(*We pose NORMA, holding the beautifully formed trays. We discover she has already begun to win awards for her basketwork. Fade to NORMA's hands holding the trays.*)

7

THE
MAKING
OF A
WATER JUG
BY
EVELYN PETE

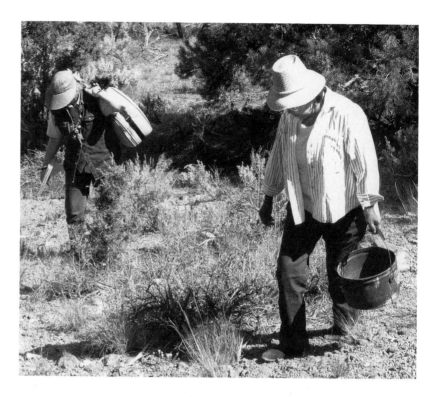

Fig. 98, top. *Evelyn carrying her pitch-gathering kettle through a piñon pine range near Duckwater, Nevada. The pitch can be very difficult to find.*

Fig. 99, left. *Evelyn collecting pitch from the piñon pine tree with her special scraper. She has rubbed dirt on her hand so the pitch won't stick to it.*

Fig. 100, right. *Evelyn testing the pitch she has gathered.*

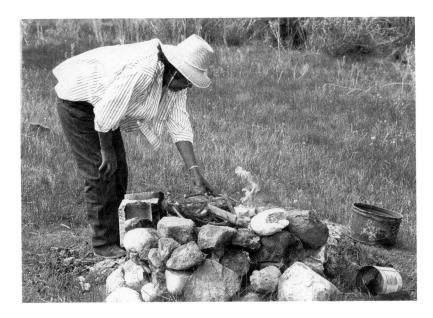

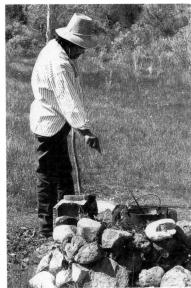

Fig. 101, left. *Evelyn starting the fire with dry rabbitbrush and building it up with pine wood. The coffee can nearby will hold boiling water for heating stones.*

Fig. 102, right. *Evelyn stirring the melting pitch with a fresh willow stick. She has added water, which will eventually boil off.*

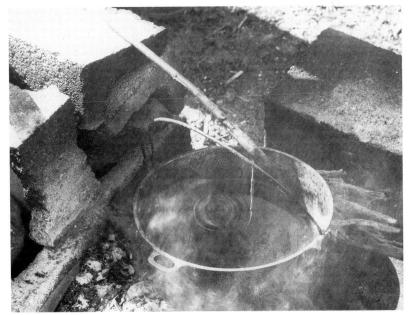

Fig. 103. *Pitch threads down from the stick as Evelyn tests the consistency. She cooks the pitch anywhere from one hour to several hours.*

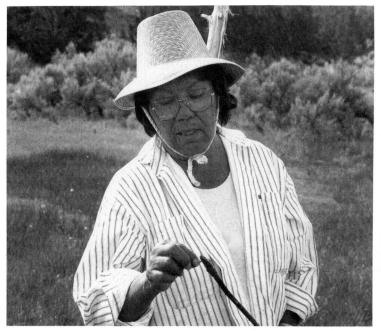

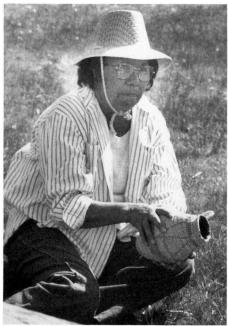

Fig. 104, left. *Evelyn determining whether the pitch is no longer sticky to the touch, in order to put it inside the basket.*

Fig. 105, right. *Evelyn rapidly shaking a basket into which the heated rocks have been dropped. "Be sure and do this on a hot day!" she cautions.*

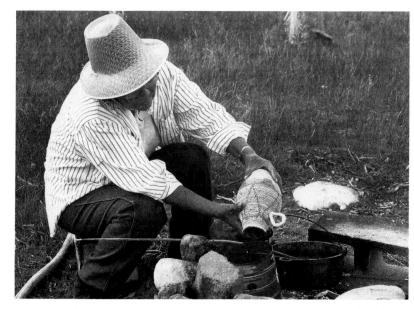

Fig. 106. *Evelyn pouring out the rocks, after the inside of the basket is coated evenly with pitch. This must be done quickly so the rocks won't stick.*

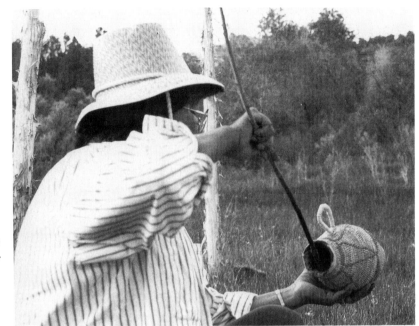

Fig. 107, top. *Evelyn patching the spots she may have missed by dipping her willow stick into the hot pitch, then daubing it on the bare places.*

Fig. 108, bottom. *Evelyn smoothing the pitch around the basket's mouth with her fingers, as the final step in this process. Note the design on the basket, which was taught to Evelyn by her mother, Agnes Penola.*[a]

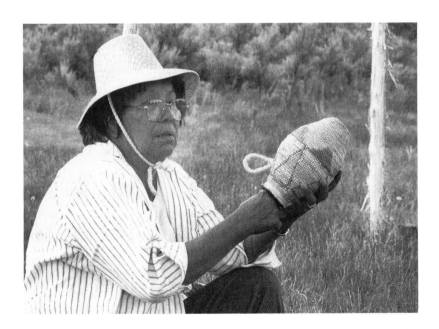

8

DANCES, CEREMONIES, AND LEGENDS

BASKET DANCE

The Basket Dance is performed by two dance groups, which raise their own money for dancing outfits and traveling expenses. Women and small girls participate in the Basket Dance. According to Faye Melendez, "Kids dance too, because we're teaching them the tradition as our parents and grandparents did for us. It doesn't matter how old or how young anybody is to dance!"

Paviotso singers and dancers

This group was formed in the late 1970s, originally as a family group known as the Paviotso-Shoshone group, to enter the annual Fallon, Nevada, All-Indian Stampede and Rodeo.

They have been responsible for reviving many of the old Paiute dances that were nearly forgotten. Their Paiute and Washoe families met with their Shoshone family members to design dance outfits, practice old songs and dances, look at old photos, and collect family willow baskets. They decided to adopt the Shoshone name Paviotso to distinguish themselves from the other Indian dance groups and tribes. According to a brochure they distribute, the word means "all Indian people who live in and about the marshlands west of the Nevada Shoshone people."

Group organizer Norm DeLorme first saw the Basket Dance when he was a small boy. He says the dance came from a Pyramid Lake pageant in which Chief Winnemucca once participated. This is a blessing dance, blessing the materials and the basket as a sacred container and a sacred gift to the people. When they dance the Basket Dance, the women are praying for abundant food for the coming year. The dance is performed carrying handmade willow baskets used to prepare and store food through the

winter.[1] Norm says they always dance with food baskets, not pack baskets.

The Paviotso group, which has been growing in number, performs at many Indian events and schools in northern Nevada.

The Screaming Eagle Dancers

We first saw this colorful group, which is a family group comprised of young people, performing on the grass at a Native American demonstration at the Stewart Museum. Our attention was riveted on the strong and hearty drummer, the first woman drummer we had seen. Later, we traveled to the Walker River Paiute Reservation at Schurz to meet Patty Hicks.

Patty started the group as the Wovoka Dancers in the 1970s; now she teaches their children. All are from the Walker River Indian Reservation. "This is a gift to give your children, to give them self-esteem and so they will be proud of who they are. Our Paiute language and songs and dances are disappearing. This group was formed to preserve them by giving them

Fig. 109. *Left to right: Ashli Harjo, Alyssa Gibbs, Sunshine Kenton, and Monetta Moody, of the Screaming Eagle Dancers (a Paiute dance group from Schurz, Nevada) performing the Basket Dance at the Stewart Indian Museum, Carson City, Nevada.*

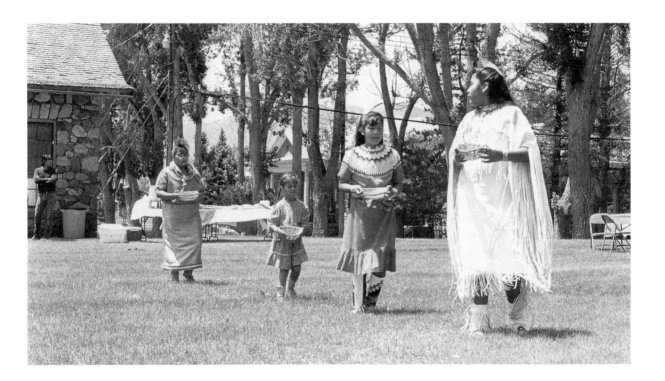

as a gift to our children here. After all, our young ones are our hope and our future," she says.

Patty learned many of the dances herself when she was young; she says she has always been involved with children. The group has performed in Hawaii and in 1976 went to the Bicentennial Celebration in Washington, D.C., where they danced by the reflecting pond at the Lincoln Memorial.

The Screaming Eagle Dancers perform the Basket Dance as a way of honoring the art of making willow baskets, which they say was essential in order to gather pinenuts, roots, and wild berries, so important in bringing food for the People.

The Wind Spirit Dancers

This is an active dance group from Yerington. It is not known if they dance the Basket Dance.

THE WASHOE GIRLS PUBERTY CEREMONY

As a girl reaches the threshold of womanhood, her parents hold a puberty dance, one of the most important ceremonies held by the Washoe people.

The girl fasts for four days. This is a strict fast and has a great deal of bearing on what she will grow up to be. If she fails to keep the fast, she will go hungry in later life. During this time she does things that will help make her healthy when she grows up. She prepares food and seeks wild onions, pods, seeds, and berries to give her the strength to gather and prepare much food in later life. She walks a lot and keeps busy with her daily chores—this is so when she grows up she will be ambitious.

For four days she can have no fried food or meat. This is to make her healthy and respectful, to give her a good mind so she can take care of all nature that was there before she was born.

The girl holds an elderberry stick or pole painted red for these four days. She cannot let it fall, as a symbol of strength. On the fourth night she climbs to the top of a mountain with one of her relatives. (Some people used Job's Peak for this.) Here the girl and her relative light four fires, which can be seen for miles. These fires announce the event and invite all the people to share in the dance and ceremony which follows.

She dances all night the fourth night with another girl, holding the pole and using it for support. (Later, she will hide this pole in the mountains, perhaps in the trees. It represents her life and will be planted upright so she will always remain strong.)

At sunrise the next morning, the girl faces the east. She is blessed, prayed for, and given the ritual bath by her grandmother. A special basket is used to pour the bathwater over her. It is then thrown to the crowd for someone to jump up, catch it, and keep it, as this basket will bring the owner much good luck.[2]

THE PINENUT FESTIVAL

Traditionally, the Pinenut Festival was an ancient gathering time for Indians throughout the Great Basin, who met to offer days of prayer and ceremonial dancing and ask for a good harvest the following year. Even now, elders go up to the pinenut groves and bless the nuts in a ceremony held in both the spring and the fall of the year, according to Schurz tribal elder Geraldine Whitefeather. Held the third weekend in September at the Walker River Indian Reservation at Schurz, this event has become one of Nevada's largest Indian-sponsored festivals and attracts thousands of visitors from many states and several foreign countries. The festival

Fig. 110. *Ashli Harjo holding E'sha Hoferer in his cradlebasket at the Pinenut Festival Cradlebasket Contest, Schurz, Nevada.*

begins with a prayer, but many of the events have evolved to include today's interests, such as an Indian car contest, a Little League game, an All-Indian Rodeo, a horseshoe competition, and the crowning of Little Miss Pinenut. The traditional round dance is held, but so is a country-western dance.

It's the site of Nevada's only Cradlebasket Contest, where the best of the best of Shoshone and Paiute basketmakers walk in a circle in a plaza with a piñon tree placed in the center. Friends, family members, and other interested people sit on benches and watch the parade as judges confer. There are two contests: one with babies and one without babies. The baskets are beautiful, and selecting a winner is always difficult. Judges look at the quality of the buckskin (which has been prepared in the traditional manner), the quality of the weaving, the number of beads if there is beadwork, and, finally, the quality of the design.

Handgames go on day and night all four days. Many opposing teams face each other, their continuous songs and drumbeats providing deeply haunting background music to other activities. The Walker River Tribe generously provides a delicious pot luck barbecue to all who attend; the food line stretches around the picnic grounds, and the last person in line receives as large a plateful of food as the first. The elders are always invited to come to the front of the food line in the traditional way of all Great Basin tribes of paying respect to their elders.

The round dance is held on the last night, amid loud, rhythmic drumming and traditional singing. Dancers circle the piñon tree set in the center of the plaza, and the people distribute packages of roasted pinenuts to all who dance in honor of this tree, still so important to the people.

THE LEGENDS
Origin of the Great Basin People

Long ago in the beginning, there was a great body of water around the land of the Coyote. One day as he was on one of his journeys, he saw some distant lands across the water, and he decided to explore them. Since he could not swim across the water, he tricked the waterbug into carrying him on his back. Waterbug was afraid of the Coyote, but the Coyote knew if he did not behave, the waterbug would dump him in the

middle of the water. Coyote made it safely across the water and began his journey. Along the way he met some people and stayed with them. While he was there he acquired a bride, the daughter of one of the leaders. The leader did not trust Coyote and knew he was always up to mischief. The leader wanted him to leave but knew Coyote would take his daughter along with him. So he said if Coyote would leave, the leader would give him a great gift to take with him in exchange for his daughter. Coyote, enticed by the thought that he would receive this wonderful gift, decided he could always find another bride. He agreed to the trade, and as he was leaving, the leader gave him a fine woven willow water basket with a lid and told him he was not to open the lid until he returned to his homeland.

Now, Coyote was a very curious person and had little patience. As he was traveling, he could hear sounds and movements within the basket. The sounds sounded like singing and drums beating.

Coyote thought it would not hurt to take a small peek once he returned to the other side of the water. So once he touched the land, which was far from his homeland, Coyote opened the basket.

Immediately, the little people who were inside the basket jumped out and began running in all directions. Stunned, he watched them run away. He quickly shut the lid on the basket, fearing he would lose all of them. When he returned home, he opened the basket again, finding only three little people left in the basket.

These three people stayed in this area and became the Great Basin People. That is how they began. The others who got away from Coyote were all the other Native American tribes that lived in North and South America.[3]

Paiute creation story

A mother and her daughter were camping together. The Coyote went over there to marry the daughter. The mother told them to catch a duck, to take off the big feathers first, and then to pick off the soft feathers and poke them into the water jug. The feathers would then become babies.

The mother told the daughter to carry the water jug on her back to her new home. Then the Coyote and the daughter started out walking and the water jug began to move a little. It was lots of babies moving in there!

Then the daughter said she was getting tired, and she sat down. She put the jug down slow. I don't know how long she sat there resting.

Then they started out again carrying the jug. It moved harder. They walked until they got tired and had to rest the second time. When they were rested, she put the jug on her back and go again, and the babies moved worse.

I don't know how far they go. Three times they had to rest. When she stop, the lady put the basket down slow and the coyote want to see the babies in there. Lots of babies in that water jug, and the Coyote want to see his kids. The lady said no, because her mother had told her not to open it until they got home. But the Coyote don't mind. He want to see them right away, so he pulled out the cork. Then all the babies flew out just like flies! Just like bees, they flew out every way! The Coyote tried to put his hands over the hole, but he couldn't hold them in, and all of them flew away. Only one left in there, that one got a big stomach and could not get out. The one that was left was the Paiute.

That's what the old people always say. That's why the Paiutes are here. The best ones fly away. . . . The Coyote spoil everything.[4]

The terrible giants

When Indians went camping along the piñon trees, Minnie says, a way to quiet their children when they cried was to tell them to stop or the giants would come. The giant was an Indian eater. He would call, *Na-Hut-Sa-Nea-Hut-Se!*—which means "My grandchild!" He would put caps with pitch on their heads, throw them in his big burden basket, and run away.[5]

Minnie says, "If the people don't want him they burn him up! They throw coals in his basket and burn him!"

Minnie then told this story:

"We were working at *sibge* [this word, she says, means "water running through the tules"] a long time ago, a place where my father worked, north of Austin. There was a big, big rock there with a hole inside, like a cave. We were walking around there and my mother told me, 'That's where the *Tso-wah-bitch* [giants] live.' If it was human or animal, I never know, but they eat people.

"Well, the people wanted to get rid of them, so they drove them with

fire into a cave. Then they got a lotta wood and threw to the giants' door. But the giants threw it back to the people's camp! But they threw it back, and that's how they got rid of them!

"There's a place over there north of Austin, in Silver Creek, near the mountain. A rock corral, and my mother said, 'That's the burnt giants' rocks!'"

The legend of the grandmother hero

We are sitting around an outdoor table at the Dresslerville Senior Center one summer day, as JoAnn Martinez, her sister Theresa, and their niece Norma work on their baskets and visit. The sisters' grandfather was a storyteller, and JoAnn seems to have his magic. Her voice is musical, her eyes seem to gaze far back to another time and place, and the wind ruffles her fine hair. I ask if she knows any old stories about baskets or willows.

"Well—there's the old lady that used her *dobuk* [willow threads] to"— JoAnn stops. Norma and Theresa put their work down; Theresa smiles. We pull our chairs closer, watching JoAnn's eyes grow serious in the storyteller's way that makes the story come true.

"It happened this way. There was a lot of gambling and celebration in this place.

"Parents and grandparents were together in a big lodge, celebrating. They were not watching their children. Now, away from them in another hut was an old grandmother baby-sitting her grandchild.

"Suddenly, Hanawiywiy came along! Who was Hanawiywiy? He was a great big animal-like hairy monster who ate people!

"Hanawiywiy was singing his song. The people could hear him, but they just kept up their gambling all the same. They didn't pay any attention to him. Then he came in and said the word *Wigi do'Po*!, which means 'your eyes will all turn white and you will die!' And it happened, and they all died, all except the old grandmother and her grandchild, who were still away in the other hut.

"Hanawiywiy was going to eat the people when he heard the little child cry out, so he went to get that child too.

"The grandmother quickly hid the child in her skirts, and then ran and pulled up a sagebrush. It made a hole in the ground, and in that hole they

113

hid. The grandmother pulled the sagebrush over them, and she put her cane in the sagebrush roots and twisted them so Hanawiywiy couldn't pull it out.

"Now, this was around Double Springs Flat, where Indians have always gathered for their big times. Hanawiywiy tracked those two and pulled out all the sagebrush (that's why it's bare there now), all but this one big one that wouldn't come up. He just couldn't pull it up, so he finally walked away.

"The grandmother got out, but she didn't know where to go to be safe. She had a willow thread, though, so she put like this" (JoAnn puts her own willow thread in a coil on the table with one end straight) "and pulled one end" (her finger holds the center as she pulls the straight end, her arm lifting into the air, waving the spiraling willow thread upward) "and away they went on the willow thread! They just flew off! The willow saved their lives!"

The Legend of the Stone Mother

Long ago in the Great Basin lived one large family. This was known as the Neh-muh family or the Northern Paiutes, as they are known today.

These people were gentle and kind, but one brother was quarrelsome. He swayed some of his sisters and brothers to his bad manners. The children then divided into two sides. There was a continuous bickering from day to day that led to blows, counterblows, and much physical harm.

When the parents saw that their counseling was of no avail, they decided to separate the children. This was a bitter decision, but had to be taken before murder was committed.

The father told the children that they had to move away. He sent the quarrelsome leader to the land over the tall Sierra Mountains into what today is California. This brother and his family became the Pitt River Indians.

A brother who favored the quarrelsome one was designated to the land in the cold north—today's Idaho. He and his group became the Bannocks.

Another brother was asked to go to the southland beyond the Sierra Nevada to Owens Valley in modern California. These became known as the Southern Paiutes or the *Pe tah neh quad*.

Others of this family were dispersed into bands to lands near rivers and lakes.

The parents remained, but were very sad. They were truly heartbroken when the Pitt River band returned to fight the remaining groups.

The father passed on to the Great Milky Way. Then there seemed no consolation for the wife and mother. Even at her chores of seed gathering she wailed and mourned. No one checked her whereabouts when she did not return to her *canee* [domed willow and grass house] at night.

Notice was made only when a large body of salt water appeared. Near this *pah nun a du* [salt water] was the form of the mother. She still had her burden basket on her back. She had been turned to stone. The lake was formed by the tears she had shed.

The Stone Mother is one of the Coo-yu-e Lake's tufa formations. It can be seen close to the Woh noh [Pyramid] today.[6]

The area around the Stone Mother is a sacred place to the Neh-muh for their meditation and prayer.

Washoe Creation Story

He was burned, but he did not move.

Pewetseli talked with his younger brother; he told his younger brother, "This drive yesterday was not good. Yesterday a Paiute tried to drown me. He wanted to drown me but I did not kill him."

At length they went off again; again they went off while Damalali did not move.

Then behind their backs, it was Damalali who got up.

"Damalil, Damalil," he said.

"My older brother acted as if he were big!

"He always was a coward.

"This is why the duck kept trying to kill him yesterday!

"Damalil, Damalil,

"My older brother will come tomorrow!" he said.

When they had gone off, when they had gone off fishing, when they had gone off the woman began twisting off and gathering cattail seeds which she made ready and dried. Then she burned off the fuzz.

Again the next day they went off. Then again she twisted them off and then she burned off the fuzz. She did all this.

And she sifted the seeds with a winnowing basket,

And she sifted,

She sifted them out.

After Pewetseli and Damalali had gone away, this woman did this:

Those that she sifted out she put away,

She called them cattail eggs.

She put them in different places.

She kept working. The cattail eggs which she had made ready, she scraped together.

"These will be Paiutes!" she said.

"These will be western Miwoks!" she said.

A few which were left in the middle, these she scooped together.

"They are only a few, but they will be strong!" she said.

"In fighting they will be strong!" she said.

"But those others, though they are many, they will be cowards!" she said.

"Then too these Paiutes, though they are many,

"They will be cowards!" she said.

"Then these Washo, though they are few,

"They will be mighty!" she said.

At length she put the seeds in a jug which she made ready for them. Then she gave Coyote himself a task; she said that he was to carry the jug to the Washo's Valley.

"Carry it away,

"Carry this away,

"Go swiftly, as you always do,

"Carry it to the middle of the Washo's Valley,

"There you will open it!

"Before this people will begin to grow. This jug will begin to roll around, but do not mind; your ears will be troubled with the noise! Open it only there!" she said.

At length he said, "Yes!" and carrying it, he came this way. He carried it on his back. He came this way to the foot of a pass called Juniper Pass. There the seeds became people. Beginning to fight, they made much noise. Inside the jug they began to attack one another as they always will do. The jug began to rock, Coyote became tired. "What is this I am carry-

ing on my back?" The noise troubled his ears, there he opened it. Then up into the sky, they streamed away. They went up in a white streak. The few that were left, Coyote shut in. Then he carried it [the jug] over here. In the middle of the Washo's Valley he opened it.

Behind him the woman went away. She kept thundering as she went along.

> She went away,
> She kept thundering along,
> She went away, away southward she went
> To the south she went.

There she settled down.

> Thunder always comes from there,
> All storms always come from there,
> All that grows, all that lives comes from there.[7]

9

THE
FUTURE

The Native American basket weavers we interviewed are proud to be bearers of an ancient tradition, bringing it down to the next generation to carry on the culture of the family and the tribe.

But they worry that fewer people are making baskets now. There seem to be two primary reasons for this: lack of available materials and little respect paid to the tradition itself.

The first constraint for weavers is difficulty in gathering the materials they need. In urban areas, rapid housing development has eradicated the best willow patches, and the people are forced to go farther and farther away to find their willow. Will it all be gone eventually?

There has been interest by staff and others at the arboretum at Rancho San Rafael Regional Park in Washoe County to work with Indian people in planting the varieties of willow they need for their baskets. Even though an important element—communing with the spirits of the wilderness—will be lost, this option will at least serve to keep the right kind of basket willow alive and growing.

Another solution would be for managers of the public domain—the United States Forest Service and the Bureau of Land Management—to allocate land specifically for Native American basketry as well as other native plant materials. A park would be wonderful!

Solutions are needed!

The second deterrent to weavers is more personal, because it involves respect for the basket tradition. To appreciate a Great Basin Native American basket is to appreciate the fact that it has been a carrier of the culture for several thousand years. To honor this basket tradition is to look at a basket, ask about it, appreciate it, even buy it, especially when the weaver's children or other relatives are watching.

We believe there is a renaissance in Native American basketry in

Nevada. More and more Indian people are taking pride in a magnificent heritage; dances are increasing in numbers and quality of attire, songs and music are frequently heard, and more cradleboards are appearing in public places like parades and festivals. Many Indian people are making valiant attempts to learn to work with willow. Beginners' baskets are emerging for sale at powwows and other celebrations, and these baskets seem to be improving in workmanship and design. Many other people want to learn, and who will teach them? Loretta Graham, who lives in Las Vegas, is vainly seeking a teacher. Young women in Fallon, Duckwater, and other areas want to learn about their heritage; many young people read, attend celebrations, describe their heritage to white schoolmates, and dance at the powwows. Basket weaving is alive and well, despite the distractions of television and other sedentary games people play.

HOW PROSPECTIVE WEAVERS CAN LEARN

1. From their families. If not a family member, sometimes a friend will let you sit and watch her work the willow, as Irene Cline's friend did.

2. Some individuals living in colonies and on reservations offer classes from time to time. Sophie Allison was recently asked to teach a group at the Tribal Hall in Duckwater, including her granddaughter. Sophie wor-

Fig. 111. *Rebecca Eagle Lambert showing her daughter Yvonne how to split the willow.*

Fig. 112. *Norma Smokey inspecting the willows she has prepared as her aunt and teacher, JoAnn Martinez, looks on.*

ries that if she begins, the students won't follow through. One girl, she says, didn't want to get her shoes dirty while cutting willow at the creek. "They don't know how hard it is." Theresa Jackson and JoAnn Martinez have taught several workshops on traditional Washoe skills, including basketry.

3. Through grants and apprenticeship programs offered by state arts councils. Minnie Dick received a Folk Arts Grant from the state of Idaho to travel to Owyhee to teach basketry. She went about it a different way: she brought a breadboard and taught her six students how to split willow with a knife against the board. It was easier that way, she says, and four students gradually learned the right way to split willow.

Many of the weavers and apprentices mentioned in this book received grants from the Nevada State Council on the Arts Folk Arts Apprenticeship program. This fine program pairs an experienced weaver with a novice, and many new basketmakers are emerging. To receive more information on the Apprenticeship Programs, which cover all traditional arts and skills of the people of Nevada, contact the Nevada State Council on the Arts in Carson City and ask for the folk arts coordinator.

The Mono County, California, Arts Council offers many classes on traditional Washoe arts and skills, including basket weaving. Their popular summer workshops are usually full.

HOW YOU CAN HELP

When an Indian basket is purchased, it is important that individuals as well as institutions document that piece, including the weaver's name, tribal affiliation, date purchased, and date made. (See sample documentation sheet.) In this way, the makers and their families receive acknowledgment for their work. Additionally, attaching makers' names to baskets may add to their value.

Documentation

Collectors can document their baskets by using the reference form (see Table 1) developed by Norm DeLorme. Please duplicate it and keep it with your other important papers. Attach a photo of the basket, if possible. If you know how your basket was woven, use the complete form; otherwise, complete sections 1, 3, 5, and 6, and on the back of the sheet describe in your own words the basket's design and style.

Also, owners need to have instructions filed as to disposition of their Indian baskets after they die. Do you want to return your basket to the family of the weaver? Leave it to a child or interested family member? Donate it to a collection?

Museums and other exhibit sites would be well served to learn names of the basket weavers in their collections and, when possible, to label those baskets with the makers' names and tribal affiliations. Not only does this practice educate non-Indian viewers about the similarities and differences among tribes; it can do the same for Native people, with the added value of honoring the maker by name. Native American families do not want to attend exhibits or leave their baskets to public entities that do not bother to acknowledge the maker and the tribal affiliation. Persons who frequent museums have every right to ask for identification of baskets and other Native work; these are public institutions, funded with public dollars, answerable to the public.

Owners who elect to bequeath their Native American baskets or collections to a private or public institution can and should stipulate that their baskets be labeled and displayed with the name of the weaver. And people who support universities, museums, and historical societies should ask that baskets in those collections be identified to the degree it is possible

**TABLE I
BASKET
DOCUMENTATION
SHEET**

I. Basket Number _____

Made by_____

Basket type_____
(cradlebasket, round basket, seed
beater, winnowing tray, etc)

Cultural Affiliation _____

Date Acquired _____

Acquired by _____

Trade for _____

Purchased for _____

Gift from _____

Other _____

2. Weaving Technique

Coiled	_Stitched_	_Twined_
__one-stick	__close stitch	__plain twined
__two-stick	__non-interlocking	__twill twined
__three-stick	__gap stitch	__3-strand twine
__bundle	__with inter-stitch	__reinforced rod

3. Measurement, Condition, Use

Measurement	_Condition_	_Use_
__inches tall	__old/used	__utility
__inches wide	__old/unused	__fancy
__inches long	__new	__commercial
__rim diameter	__undamaged	__gift
__self rim	__damaged	__show/skill
__false-braid rim	__mended/repaired	
__diagonal-stitch rim		

4. Form, Decoration, Beading

Form	_Decoration_	_Beading_
__bowl	__sewn w/willow	__bead size
__tray	__redbud	__l-bead peyote
__winnower	__black fern root	__l-bead diagonal
__cone	__brown fern root	__2-bead peyote
__jug	__devil's claw	__2-bead diagonal
__bottle	__sunburned willow	__3-bead lace
__miniature	__unscraped willow	__threaded btwn.
__cradle	__dyed willow	willow
__ boy	__wild rose	__beaded
__ girl	__sedge root	background
__other	__feathers	color:_____
__lidded	__buckskin	_____
__handles	__cloth	
__neck	__Other	
__pedestal base		

5. Design

__simple	__isolated	__serrated
__fancy	__zigzag	__triangles
__complex	__geometric	__diamonds
__horizontal	__floral	__other
__diagonal	__zoomorphic	

6. Recorded by _____ **Date** _____

to do so. In some cases, it is already too late; in others, there may still be ways to locate documentation on the weavers' names, through family members who can often visually identify their own family styles. Why should a magnificent basket be any more anonymous than any other work of art? Exhibiting groups of baskets and calling them simply "Indian baskets" is degrading to a tradition far greater and longer than any picture that was ever painted by any artist.

One institution that does provide documentation for their baskets whenever possible is the Great Basin Museum at the University of Nevada's Department of Anthropology. Nearly every recently woven basket exhibited from Nevada carries a label identifying the name of the maker.

We were shocked to discover that Indian Smoke Shops and other gift shops frequently do not know the names of the weavers of baskets which are for sale in the shops. Indian people also need to acknowledge their creative artists by name. And weavers can begin to attach tags to the baskets they sell, containing their name, their tribal affiliation, and the date the basket was completed.

As one way of honoring a commitment to carrying on the Native American basket tradition, the author and the photographer of this book have committed a portion of their income from proceeds of sales to the Lulu K. Huber Native American basket collection at the University of Nevada, Reno, and the Washoe Cultural Center, at this date yet to be constructed.

WHERE TO FIND NATIVE AMERICAN BASKETS

Several of the state and county museums in Nevada have very good basket collections available for public viewing. There are several places in Nevada where Indian baskets can be purchased. Some of the best are located at reservation and Indian specialty shops. The I-80 Smoke Shop at Wadsworth and the Pyramid Lake Marina on the shores of Pyramid Lake exhibit and sell Paiute-made work. The Crosby Lodge at Pyramid Lake and the nearby Indian Store on the Pyramid Lake Highway sell Indian crafts as well.

One of the best stores selling work from all of the Nevada tribes is the

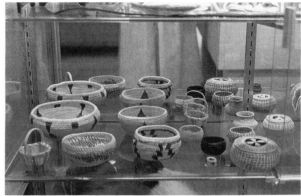

Fig. 113, left. *The Stewart Indian Museum, in Carson City, Nevada, is part of a complex of old-stone buildings and lawns that used to be the Stewart Indian School. A Native American Board of Directors now governs this site where Indian children were once forced to attend school.*

Fig. 114, right. *Baskets made by Native American Great Basin artists are on display and for sale at the Stewart Indian Museum Gift Shop, Carson City, Nevada.*

Stewart Indian Museum Gift Shop near Carson City. This store actively seeks Native American basket weavers with tribal affiliations in this area and identifies each artist accurately.

Historical museum gift shops such as the Churchill County Museum in Fallon, the Nevada State Museum in Carson City, the Northeastern Nevada Museum in Elko, and the Nevada Historical Society in Reno are good places to look. Minute Man Country Store in Wabuska and Calli's Corner on Curry Street in Carson City carry a complete line of Betty Rogers's horsehair baskets and some of her daughters' too. The Eagle sisters and the DeLormes often have their baskets in Wade's Silver Shop in Reno. This is just a small list of outlets with which we are familiar; we are sure there are many more. Tribal Smoke Shops, located on colonies and reservations, are good places to start.

Several of the basketmakers sell their work at the Reno-Sparks Indian Colony's Christmas Art Market, held the second weekend in December. The Colony's Numaga Indian Days in September provides booths for shoppers, as does the annual September Powwow at Stewart. At the Clark County Fair, held the second week of April in Logandale, Virginia Lanning Tobiasson coordinates the Heritage Village, where viewers can enjoy exhibits and basket-weaving demonstrations. Dances and celebrations at Lake Tahoe and Carson City are other places where traditional Native people may bring along some baskets to sell. Interested collectors need to read *Nevada Magazine* and follow the powwow trail. Many Native events, such as the Fallon All-Indian Rodeo, attract basket artists. The Washoe Trading Post in Washoe Valley is another basket source. We encourage

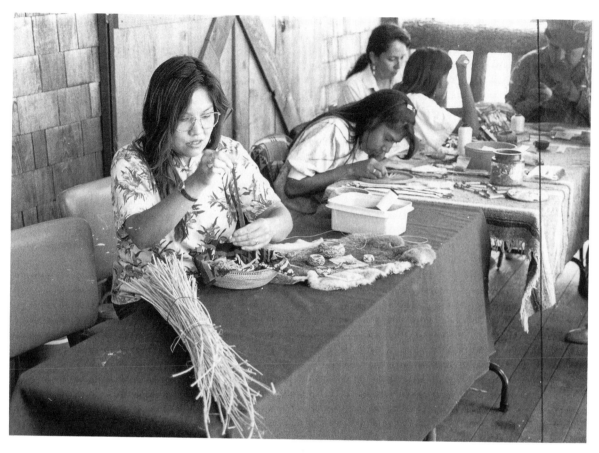

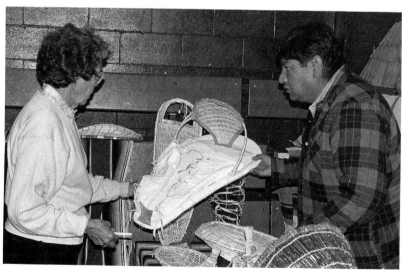

Fig. 115, top. *Left to right: Rebecca Eagle Lambert demonstrating her basketry; Adrienne Garcia and Celia DeLorme, daughters of Bernie DeLorme (extreme right), at Tallac, south shore of Lake Tahoe, California.*

Fig. 116, bottom. *Norm DeLorme discussing prices for baskets with Lilly Sanchez during the Reno-Sparks Indian Colony's Christmas Market.*

would-be buyers to be persistent detectives when seeking out baskets.

Emerging as the largest basket-related event in the area is Wa She Shu E'deh, which means "Washoe Peoples' Land," a festival held in late July at Tallac Historic Site, South Lake Tahoe. Sponsored by the Washoe Tribe of Nevada and California, this four-day event bursts with activity. Highlights include a basket-weavers' exhibition and market, where awards are given for the finest baskets, and talks on baskets and contemporary Native American art are featured. Many of the people mentioned in this book participate in this well-organized, exciting event.

CARE

Your basket can be dusted with a gentle vacuum brush and gently wiped with a soft, dampened cloth from time to time. Try not to pick it up by the rim as this vulnerable area receives the most wear and will deteriorate first. Also, it is good not to put your basket in direct sunlight if you're worried about colors fading or the willow turning brown. Owners of old baskets would do well to consult with a museum conservationist as to their care and maintenance.

If you own a Nevada Indian basket or a basket collection, congratulate yourself! You have a priceless treasure. You are honoring tradition.

NOTES

Chapter 1. This Dynamic Land

1 Margaret M. Wheat, *Survival Arts of the Primitive Paiutes*, 1.
2 Stephen Trimble, *The Sagebrush Ocean: A Natural History of the Great Basin*, 6.
3 Hugh N. Mozingo, *Shrubs of the Great Basin: A Natural History*, 1.
4 Trimble, *The Sagebrush Ocean*, 19.
5 Sessions S. Wheeler, *The Desert Lake: The Story of Nevada's Pyramid Lake*, 126.

Chapter 2. The People

1 Personal conversation, April 1992.
2 JoAnn Nevers, *Wa She Shu: A Washo Tribal History*, 3.
3 Robert Lowie, "Shoshonean Tales," 200. This version continues: "The old man had gone to hunt for deer and in his absence the woman made a mark by the fire with her foot, then she went out. When he returned he noticed the mark but did not know whose it was, so he called out, 'Come, nothing is going to hurt you.' Then she came in with some *tupu'c* seed. She did not lie by him for four days in his lodge but moved a little closer to him every day. On the last evening she boiled some deer meat for him. He said, 'Look out, some kind of being may come in and eat you.' She handed him the meat and he ate it. Then they lay down together and got married.

"They prepared large water bottles [ed. note: these are pitched baskets]. After a while they heard talking by two males and two females inside the jugs. After a while these beings were big enough, so the couple let them get out. This is how the Indians originated. When the boys were big, they made arrows for themselves and shot at each other. The old man got angry and told them to go away wherever they wished. The Paviotso were put over by the Walker River, and Ute in another place, the Shoshoni and Pitt River in still other localities."

4 The Stewart Indian School, located southeast of Carson City, Nevada, closed

in the 1950s. It has been converted into an Indian-operated Native American cultural center, with a museum and gift shop. Many ceremonies and pow-wows are held there throughout the year.

5 Lecture by Amy Dansie to Great Basin basketmakers, Nevada State Museum, spring 1992.

6 "Peoples of the Sage" exhibit materials, High Desert Museum, Bend, Oregon, August 1990.

7 Citizen Alert Caravan lecture by Joe Sanchez Jr., April 12, 1992.

Chapter 3. The Materials

1 *Salix*. Hugh N. Mozingo, *Shrubs of the Great Basin: A Natural History*, 112.

2 *Reno Gazette-Journal*, May 7, 1989, p. 3C.

3 Sometimes Rebecca Eagle finds her whole willow shoots have been stored for too long and need moisture before she can begin the splitting process. She digs a hole in the ground and buries them. Then she covers them with more dirt and waters the area with a hose to keep it moist. After about a week, Rebecca says, the willow gets pliable again.

4 *Prunus virginiana* var. *demissa*. Catherine S. Fowler, "Subsistence," in *Handbook of North American Indians*, Warren d'Azevedo et al., eds., vol. 11, 78.

5 Although birch is not listed as a tree native to Nevada's Great Basin, Emma Bobb identified it as such. A representative of the Villager Nursery in Truckee, California, identified it as *Betula occidentalis* and said these birch do grow in Nevada.

6 *Cercis occidentalis*. Catherine S. Fowler and Lawrence Dawson, "Ethnographic Basketry," in *Handbook of North American Indians*, d'Azevedo et al., eds., vol. 11, 731.

7 Mr. Burns is a Western Mono from North Fork, California.

8 *Rosa woodsii*. Mozingo, *Shrubs of the Great Basin*, 184.

9 *Proboscidea parviflora*. Wild devil's claw is indigenous to the Great Basin, although it does not grow in northern Nevada. The DeLormes grow a cultivated version, originally domesticated by the O'odam people of Arizona. The seeds were given to the DeLormes by Luella Tom of Moapa. The domestic plant has much longer claws for pulling strips to use in basket weaving.

10 *Pteridium aquilinum*. Fowler and Dawson, "Ethnographic Basketry," 731.

Chapter 4. The Baskets

1 Personal conversation with Norm DeLorme, March 16, 1993.

2 "Cradleboards Offer Comfort, Protection for Newborns," *Native Nevadan* (November 1984): 15.

3 The Paiutes, including many little children, were forced to move north through heavy winter snow, across mountains and the Columbia River, to Yakima. Several died during the brutal winter march. Ellen Scordato, *Sarah Winnemucca: Northern Paiute Writer and Diplomat*, 90.

4 "Cradleboards," *Native Nevadan* (November 1984), 15.

5 Ibid., 14.

6 Conversation with Norm DeLorme, March 16, 1993.

7 "Cradleboards," *Native Nevadan* (November 1984), 14.

8 Ibid., 15.

9 Morning Manning's poem appeared in the 1988 Elko County school district writers' booklet, courtesy of Nevada State Education Association. She was in Mrs. Jim's third grade class in the Owyhee Combined Schools.

10 Edward C. Johnson, *Walker River Paiutes: A Tribal History*, 11.

11 Kit Miller, "Pinenuts a Lasting Tradition for Great Basin Indians," *Native Peoples Magazine* (Fall 1992): 48.

12 JoAnn Nevers, *Wa She Shu: A Washo Tribal History*, 3.

Chapter 5. The Weavers

1 Warren d'Azevedo et al., eds., *Handbook of North American Indians*, vol. 11, 496.

2 Tourist information publication of Tallac Historic Site, South Lake Tahoe.

3 Citizen Alert, a statewide environmental organization with a Native American component, conducts an annual members' trip through central Nevada.

4 Donald R. Tuohy and Doris L. Rendall, *Collected Papers on Aboriginal Basketry*, 31.

5 Mr. Bill Rosse, of the Yomba Shoshone tribe, said in a conversation in June 1992 that many elders do not want to have their photographs taken, as they believe their spirits will leave with the picture.

6 Robert has since left this employment.

7 *Pinus sabiniana*. Craig D. Bates and Martha J. Lee, *Tradition and Innovation: A Basket History of the Yosemite–Mono Lake Area*, 218.

Chapter 8. Dances, Ceremonies, and Legends

1 Paviotso Dancers brochure, 1990.

2 As told by Theresa Jackson. This ceremony is still held from time to time in

Washoe country. See also Warren d'Azevedo et al., eds., *Handbook of North American Indians*, vol. 11, 486.

3 Story as told by Leah Brady with help from family elders.

4 As told by the late Paiute elder Wuzzie George. Margaret M. Wheat, "Pitch 'n Willows," *International Native Arts and Crafts,* 22.

5 Minnie Dick, Shoshone/Washoe elder, remembers childhood stories about the terrible giants. She laughs, remembering the old stories, but she becomes serious as she tells us the story. Minnie says there is no written way to say the words.

6 Pyramid Lake Paiute legend. Nellie Shaw Harnar, *Indians of Coo-yu-ee Pah (Pyramid Lake),* 16 (includes vocabulary). Another version of the Stone Mother Legend, related by Avery Winnemucca, can be found in *Pyramid Lake: Legends and Reality,* by Doris Cerveri.

7 Grace Dangberg, *Washo Tales: Three Original Washo Indian Legends,* 3.

Photo Captions

a "Mom showed me how to make designs on baskets. You have to count every stitch," she added. The orange color in the design comes from Rit dye. Evelyn finds a similar natural dye from a type of holly that grows on the mountains nearby. The basket, which is tightly coiled, is made to be very sturdy. Evelyn uses thicker willows and tighter stitches.

 Evelyn also says that piñon pitch has other uses as well. It can be used for blessings, and if it is dropped on hot charcoal when someone is having a bad dream it will drive "evil things" away. To use the pitch as a medicine, Evelyn boils it with sagebrush so it can be chewed.

b You shake the chips in the air and catch them, winning points according to which color is up. If you miss, it's the next person's turn. Developing skills at this game teaches the player some of the shaking and throwing skills needed later to prepare the pinenuts. Lilly Sanchez made the *wen-du* (her pronunciation) shown above.

GLOSSARY

Paiute Words for Baskets

cotia: close-twined hat

hupi: cradlebasket

kudusi: cone (burden) basket

opo: cooking basket

os.a: (or *si.os.a*) water bottle

wono: open-twined basket

yad.a: open-twined winnowing
 parching tray [1]

Shoshone Words for Baskets

biquop: broken water jug

ga gudu (or *ga koo du*): small cone
 basket

koh no: cradlebasket

pa wuthe: water jug

teh'wa: small winnowing basket

tima: parching tray

wendu: cone basket

wosa (or *gow'was*): large cone or burden
 basket

yantu (or *y'andu*): large winnowing
 basket [2]

Washoe Words for Baskets

bikus: cradlebasket

degikup: round basket

gadu: willow shelter

giuliu: large conical cooking basket

hemu: willow

itmago: coarse pinecone basket

itmahadas: small mush basket bowl

keotip: pitched water jug

mamayt: large open-weave burden
 basket

singam: close-weave coiled basket,
 one-rod foundation

tapuli tugabul: seed beater

tugabul: open-weave winnowing tray

wastangam: small open-weave burden
 basket [3]

1. Warren d'Azevedo et al., eds., *Handbook of North American Indians*, 722.

2. Supplied by Shoshone elders Minnie Dick, Evelyn Pete, and Lilly Sanchez.

3. Educational brochure printed by the Washoe Cultural Center and Washoe Tribe Education Department.

BIBLIOGRAPHY

Bates, Craig D., and Martha J. Lee. *Tradition and Innovation: A Basket History of the Indians of the Yosemite–Mono Lake Area.* Yosemite Association, Yosemite National Park, California, 1990.

Bravo, Leonore M. *Rabbit Skin Blanket.* Nevada?: L. M. Bravo, 1991.

Bureau of Land Management. *Native Americans of Nevada.* Las Vegas: Nevada Historical Society, n.d.

Cerveri, Doris. *Pyramid Lake: Legends and Reality.* Sparks: Western Printing and Publishing Co., 1977.

Cohodas, Marvin. *Degikup: Washoe Fancy Basketry 1895–1935.* Vancouver: University of British Columbia Fine Arts Gallery, 1979.

Dangberg, Grace. *Washo Tales: Three Original Washo Indian Legends.* Nevada State Museum Occasional Papers no. 1. Carson City: Nevada State Museum, 1968.

d'Azevedo, Warren D., William C. Sturtevant, Catherine S. Fowler, Jesse D. Jennings, Don D. Fowler, and William H. Jacobsen Jr. *Handbook of North American Indians.* Vol. 11 (Great Basin). Washington, D.C.: Smithsonian Institution, 1986.

Fowler, Catherine S. *Great Basin Anthropology: A Bibliography.* University of Nevada, Desert Research Institute Social Sciences and Humanities Publication 5, 1970.

Harnar, Nellie Shaw. *Indians of Coo-yu-ee Pah: The History of the Pyramid Lake Indians, 1843–1959, and Early Tribal History, 1825–1834.* Sparks: Western Printing and Publishing Co., 1978.

Hopkins, Sarah Winnemucca. *Life among the Piutes: Their Wrongs and Claims.* Bishop: Chalfant Press, Inc., 1978.

Johnson, Edward C. *Walker River Paiutes: A Tribal History.* Schurz: Walker River Paiute Tribe, 1975.

Lowie, Robert. "Shoshonean Tales." *Journal of American Folk-Lore* 37 (1924).

McGinty, Bob. *1992 Elko County Writers' Festival.* Elko: Nevada Department of Education, 1992.

Miller, Kit. "Pinenuts a Lasting Tradition for Great Basin Indians." *Native Peoples* 5, 5 (1984).

Mozingo, Hugh N. *Shrubs of the Great Basin: A Natural History*. Reno: University of Nevada Press, 1987.

Nevers, Jo Ann. *Wa She Shu: A Washo Tribal History*. Reno: Inter-Tribal Council of Nevada, 1976.

NEWE: A Western Shoshone History. Reno: Inter-Tribal Council of Nevada, 1976.

NUMA: A Northern Paiute History. Reno: Inter-Tribal Council of Nevada, 1976.

NUWUVI: A Southern Paiute History. Reno: Inter-Tribal Council of Nevada, 1976.

Scordato, Ellen. *Sarah Winnemucca: Northern Paiute Writer and Diplomat*. Reno: Inter-Tribal Council of Nevada, 1976.

Trimble, Stephen. *The Sagebrush Ocean: A Natural History of the Great Basin*. Reno: University of Nevada Press, 1989.

Tuohy, Donald R., and Doris L. Rendall, eds. *Collected Papers on Aboriginal Basketry*. Nevada State Museum Anthropological Papers no. 16. Carson City: Nevada State Museum, 1974.

Wheat, Margaret. *Survival Arts of the Primitive Paiutes*. Reno: University of Nevada Press, 1967.

———. "Pitch 'n Willows." *International Native Arts and Crafts*, no. 1 (1976).

Wheeler, Sessions S. *The Desert Lake: The Story of Nevada's Pyramid Lake*. Caldwell, Idaho: Caxton Printers, 1980.

INDEX

Numbers in italics refer to the page number where a photograph appears.